The

GREATEST MUSIC STORIES NEVER TOLD

ALSO BY RICK BEYER

The Greatest Stories Never Told
The Greatest War Stories Never Told
The Greatest Presidential Stories Never Told
The Greatest Science Stories Never Told

HARPER

An Imprint of HarperCollins*Publishers*
www.harpercollins.com

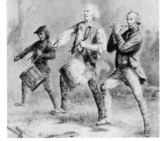
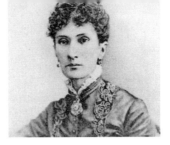

HISTORY presents . . .

The

GREATEST MUSIC STORIES NEVER TOLD

100 *Tales from Music History to*
Astonish, Bewilder, and Stupefy

Rick Beyer

HarperCollins books may be purchased for educational, business, or sales promotional use. For information, please write: Special Markets Department, HarperCollins Publishers, 10 East 53rd Street, New York, NY 10022.

FIRST EDITION

Library of Congress Cataloging-in-Publication Data
 Beyer, Rick.
 The greatest music stories never told : 100 tales from music history to astonish, bewilder, and stupefy / Rick Beyer.—1st ed.
 p. cm.
 ISBN 978-0-06-162698-2
 1. Music—Miscellanea. 2. Rock music—Miscellanea. 3. Jazz—Miscellanea. I. Title.
 ML160.B585 2011
 780.9—dc22 2011006272

11 12 13 14 15 OV/QGF 10 9 8 7 6 5 4 3 2 1

To see videos and hear songs
related to the stories in this book, go to
www.greateststoriesnevertold.com/musiclinks

W hat does Marie Antoinette have to do with "For He's a Jolly Good Fellow"? Which hugely popular song was written in a fit of anger at actor Robert De Niro? How was a musical genius of the 1600s literally killed by his own conducting? Why has one country run through eight versions of its national anthem in the last hundred years—three of them written by the same person? How did an idea for a sitcom inspire the Woodstock music festival? And why is a virtual unknown named Ivan Vaughan arguably the most important person in the history of rock 'n' roll?

The fascinating answers to those questions and many more lie within.

This is the fifth in my series of Greatest Stories Never Told books, produced in conjunction with HISTORY®. Music may be older than we are— some scholars think *Homo sapiens* got the idea from Neanderthal man. No wonder then that its long history is filled with such a host of amazing tales. Among them: a symphony that helped spark a revolution, a ballet that started a riot, a military song that saved the life of a president, and a musical instrument invented by Ben Franklin that was reputed to both heal the sick and drive the healthy insane.

Working on this book gave me a wonderful opportunity to range over a

dizzying array of genres and topics: jazz, classical, country, rock 'n' roll, hip-hop, show tunes, composers, band names, song lyrics, instruments, technology, controversies, and more. The result is a book filled with the quirky kind of history that I just can't get enough of: the hit song born in a history class, the monk behind do-re-mi, and the convict who sang himself out of jail. And let's not forget Waltz King Johann Strauss, who hired thugs to derail the career of another composer—his son!

If you're looking for surprising music firsts, this book has got 'em! America's first recording star and music video—both from the 1890s. Beatlemania? That was nothing compared to the Lisztomania that swept Europe a century earlier. Fascinating tales about the first jazz musician, the first radio jingle (it saved a brand that's still popular today), the first rock 'n' roll song, and the first singing telegram—sung by an operator with the lusciously appropriate name of Lucille Lipps. These truly are stories to astonish, bewilder, and stupefy.

Some stories are about musicians who are household names: Mozart, Louis Armstrong, Paul McCartney. Then there are characters that most people have never heard of, like the New York banker who wrote the lyrics to one song in his entire life—but boy, was it a doozy! There are songs so

familiar you hardly even think about where they came from: "Happy Birthday," "Jingle Bells," "Mary Had a Little Lamb." Yet each has a complicated and compelling story behind it.

I'm the son of an opera fan, the father of an electronic fusion musician, and the husband of a folk DJ. I grew up on the Beatles and the Rolling Stones but also came to love show tunes and Steve Goodman. My playlist runs the gamut from Abba to Warren Zevon, and includes selections from JS Bach, Johnny Cash, Muddy Waters, and the US Marine Corps Band. From this musical melting pot has emerged the book you hold in your hand. The stories inside are carefully researched, each as true as I know how to make it. I hope you enjoy reading them as much as I have enjoyed finding them and bringing them to you.

The

GREATEST MUSIC STORIES NEVER TOLD

THE MOTHER OF ALL GOLDEN OLDIES

A song that will really take you back

More than 3,400 years ago in the Mediterranean port city of Ugarit, now part of Syria, an unknown composer wrote a hymn in praise of Nikkal, the wife of the moon god. The words and music were carefully chiseled into a stone tablet.

It is the oldest surviving song in the world.

The tablet was discovered in the 1950s, but it wasn't until the 1970s that University of California at Berkeley professor Anne Kilmer was able to decipher some of the cuneiform figures on it as musical notation. She recognized them from other Babylonian tablets she had already analyzed, including a four-thousand-year-old instruction manual for tuning an

ancient stringed instrument called a lyre. The song appeared to have been written in a seven-note scale similar to the one we use today.

Amazingly, Kilmer was able to reconstruct a version of the song note for note, so that the lost tune could be played once again for modern ears.

A little late for royalties, however.

The song is written in the ancient Hurrian language. The exact lyrics are unclear, although the name of Nikkal is easily recognizable, and Kilmer has translated one phrase as "Thou lovest them in thy heart."

Versions of the "Hymn to Nikkal" have been recorded by several modern artists including musicologist Richard Crocker and Syrian pianist Malek Jandali.

The exact location of the Bronze Age city of Ugarit was unknown to modern archaeologists until a Syrian farmer accidentally opened an old tomb while plowing a field. Subsequent excavations have revealed one of the most important cities of ancient times.

DIVINE HARMONY

Secrets of the brotherhood

They were considered shadowy, mysterious, even dangerous. As members of a religious brotherhood, they observed a strict code of secrecy and loyalty. They were vegetarians who wore white robes and practiced sexual abstinence. It was said that they ruthlessly executed anyone who violated their code.

And they worshipped numbers.

The Pythagoreans were the original math geeks. They believed that numbers were magical, and could reveal the divine mysteries of the universe. Odd numbers were considered male; even numbers, female. They even associated concepts such as justice (4) and marriage (5) with numbers.

The brotherhood was founded by a Greek named Pythagoras, who came to be regarded by his followers as semi-divine. Today most people associate the name with high school geometry and vague memories of the Pythagorean theorem.

But these mathematical mystics also laid the foundations for modern Western music.

They showed that the relationships between musical notes could all be expressed mathematically. That plucking a string two times longer than another will play a note an octave higher. That two strings, one 1.5 times as long as the other, will sound together in a perfect fifth. Thus they laid the foundation for music more complex and beautiful than ever before.

A marriage of math and music that would prove harmonious indeed.

According to legend, one member of the brotherhood, Hippasus of Metapontum, was drowned for bringing to light their most disturbing secret. The Pythagorean theorem says that a right triangle one unit long on each side has a hypotenuse that is the square root of 2. That's an irrational number. In other words, it can't be represented as a ratio of two whole numbers. Since the Pythagoreans believed whole numbers were the basis of the whole universe, they didn't want anyone else to know that there were other numbers that weren't whole.

Pythagoras and his followers seemed to have a thing about beans:

> Keep your hands from beans, a painful food:
> As Pythagoras enjoined, I too urge.
>
> —PYTHAGOREAN POET CALLIMACHUS

> Wretches, utter wretches, keep your hands from beans.
> —PYTHAGOREAN POET EMPEDOCLES

Although it may be that the Pythagoreans thought beans unclean, some scholars believe these injunctions might be a sort of code for urging sexual abstinence. (Pythagoras apparently had little to contribute to the development of the love song!)

FIRE IN THE SKY

The true story behind Rome's most famous musician

Nero fiddled while Rome burned." The familiar saying describes a leader attending to his own pleasures instead of dealing with an unfolding catastrophe. But Nero led efforts to fight the fire that devastated Rome, and the violin wouldn't be invented for more than a thousand years. So what's the story?

After ten years as emperor, Nero was widely despised. His debauchery and personal extravagance were legendary. He had murdered his mother two years before. Fancying himself a skilled performer on the lyre, an ancient stringed instrument, he seemed more interested in staging public performances than governing. Nero also had a taste for self-aggrandizement. He had plans for a palace more grand than any that had come before. It would require tearing down a vast swath of the city, and the Senate was opposed.

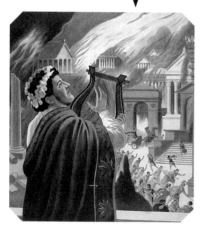

Fire broke out in July of 64 and raged for six days, destroying two-thirds of the city. Nero was instantly responsive. He rushed back from out of town to lead firefighting efforts. He threw open public buildings to the homeless, ordered the construction of emergency accommodations, and arranged for food to be brought into the city.

Did he really do it? One hundred fifty years later, Roman historian Dio Cassius said he did. "Nero mounted upon the roof of the palace," he wrote, "where almost the whole conflagration was commanded by a sweeping glance, put on the professional harpist's garb, and sang 'The Taking of Troy.'" But most modern historians believe Nero was the victim of a smear campaign by enemies who decided to "go negative" against him to drive him from power.

Nevertheless, many people were convinced that the unpopular emperor had planned the fire to make room for his palace. Rumors spread that he used the burning city as a backdrop while he played on the lyre and sang about the destruction of Troy. Seeking to evade blame, Nero needed a scapegoat. He found one in a religious sect that originated in the Middle East and was viewed with suspicion and foreboding:

Christianity.

Nero began the wholesale persecution of Christians, but it wasn't enough to keep his rule from going up in flames. He killed himself four years later after being driven from power.

The Great Fire of Rome first spread through shops in the middle of the city, then devoured walled mansions and climbed the city's seven hills. The city's narrow, winding streets exacerbated the problem. Remote districts thought immune to the fire were gobbled up by it.

> **B**laming Christians for the fire, Nero ordered that members of the sect be punished by torture and death. "They were torn by dogs and perished," wrote the Roman historian Tacitus, "or were nailed to crosses, or were doomed to the flames and burnt, to serve as a nightly illumination, when daylight had expired."

THE D'AREZZO CODE

Deciphering a musical message from the past

A poem written more than a thousand years ago holds an ancient musical code that has unlocked the secrets of music for untold millions. The poem is a hymn of praise to John the Baptist written in the eighth century by Paul Diaconius.

Ut queant laxis
resonare fibris,
Mira gestorum
famuli tuorum,
Solve polluti
labii reatum,
Sancte Iohannes

Translated into English it reads: *So that your servants may, with loosened voices, resound the wonders of your deeds, clean the guilt from our stained lips, O Saint John.*

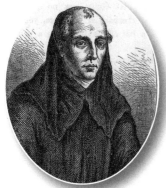

It was a Benedictine monk named Guido d'Arezzo, a pioneering musical theorist of the eleventh century, who secreted the code within the poem. He set the words to music, making the first syllable of each phrase fall on the first six notes of the major scale. Read them off . . . does it sound familiar?

ut, re, mi, fa, so, la, si

The *ut* was soon replaced with the more open-sounding *do*, probably inspired by the Latin word *Dominus* for Lord,

and *si* was eventually changed to *ti* so that each syllable would begin with a different letter.

Although it seems so simple today, *do-re-mi* was a revolutionary teaching tool that made it possible for choirs to learn complex songs in days instead of weeks.

Music . . . decoded.

Born in the year 990, Guido revolutionized the way music was written down. Before his time, the musical staff contained just two lines and was difficult to interpret. He added two more lines, utilized the spaces in between, and created notation to communicate rhythm and intervals. Guido declared that his system reduced the ten years normally required to become an ecclesiastical singer to a year. His fellow monks resisted his changes at first, but eventually embraced them.

THE BEAT GOES ON

Conducting himself to death

Jean Baptiste Lully was one of the first great conductors of classical music. Some claim that he practically invented the job. Whether or not that is true, he can claim another distinction. He is the only man to be killed by his own conducting.

In those days, orchestras were generally smaller than they are now, and might be led by a violinist tapping out the time with his foot, or an organist giving cues with one of his hands. Only occasionally was there a musical director who stood in front of the orchestra to keep time.

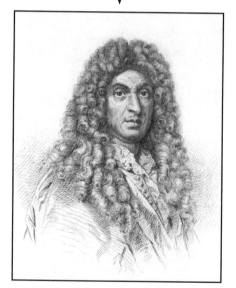

Lully was the court composer to King Louis XIV in France. A bit of a control freak, he liked to lead the orchestra with a six-foot staff that he beat upon the ground to keep time. On January 8, 1687, he was conducting a hymn to honor the king's recovery from illness.

Beating the floor furiously with the heavy staff, Lully got carried away and slammed it down on his own foot.

The Italian-born Lully started out as a dancer, comedian, and violinist. He rose to become one of the most important musical figures in France. He was a pioneer composer of French opera, and eventually became so powerful that no opera could be performed in France without his permission.

His toe throbbing with pain, Lully insisted on continuing the performance. The injury proved severe. Gangrene and blood poisoning set in, but he refused to allow the toe to be amputated. Two months later, Lully was gone.

Who knew that music could be so deadly?

In the early days of conducting, a violinist might use the bow, or a pianist a rolled-up piece of sheet music, to keep time when not playing. German violinist and composer Louis Spohr claimed to be the first to conduct with a baton at a London concert in the spring of 1820 (although some scholars believe he used it only for rehearsals). This practice didn't become common for another decade.

1693

ROOTS MUSIC

*Instrument of
bondage*

The ships that carried millions of Africans to slavery in the new world were instruments of misery, cruelty, and death. But they also brought with them instruments of a different kind.

Mortality rates on slave ships were staggeringly high. And although few captains cared about the lives of their human cargo, many were deeply concerned about the loss of profit each death entailed. Starting in the late 1600s they came up with a way to keep their captives healthy.

They made them dance.

Captain Thomas Phillips wrote in 1693 that he brought slaves on deck during the voyage to "jump and dance for an hour or two . . . by which exercise to preserve them in health." Before long it was commonplace. Music was used to encourage dancing, but if that didn't work, flogging was used to compel it.

It was soon discovered that the best way to convince the slaves to dance was to let them play their own music. Before departing with their shipload of chained and miserable captives, crewmen were sent out to gather up what one observer called "such rude and uncouth instruments as are used in Africa."

And that's how a uniquely African instrument ended up being transplanted to American shores. Today it is familiar to all, though few know its place of origin or the perverse use it was put to in support of the slave trade.

The banjo.

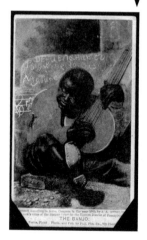

THE BANJO.

> ## THE INSTRUMENT PROPER TO THEM [THE SLAVES] IS THE BANJAR, WHICH THEY BROUGHT HITHER FROM AFRICA.
>
> —THOMAS JEFFERSON

Until the 1830s, the banjo was heard mostly on southern plantations and ignored by white America. Then minstrel shows, with white performers caricaturing African Americans by wearing blackface, introduced the banjo to a wider audience. During the 1920s it was a popular jazz instrument.

Europeans first noticed African banjos in the early 1600s. They apparently struggled to capture the name of the instrument in English. Some of the various ways they wrote it down: *banjar, banjil, banza, bangoe, bangie, banshaw,* and *banjelo.*

GODS OF GUITAR

I f someone asks you to name a few famous guitarists, who comes to mind? Jimi Hendrix would probably make the list. Eric Clapton is certainly a possibility. Then there's blues player Robert Johnson, who supposedly claimed to have sold his soul to the devil to master guitar.

Chances are you wouldn't name statesman Benjamin Franklin, composer Franz Schubert, or violin maker Antonin Stradivari. Yet unlikely as it seems, each was a guitar master in his own way.

Stradivari, of course, is famous for his exquisitely crafted violins made in the late 1600s and early 1700s. On the rare occasion that a Stradivarius goes on sale today, it fetches millions. But it turns out that he made elegant-sounding guitars as well, at least four of which survive today. Imagine Keith Richards on a Strad—both men would be shocked!

Schubert was a prolific Austrian composer who wrote nine symphonies and composed hundreds of other pieces in the early 1800s, despite the fact that he only lived to thirty-one. Schubert owned two guitars, and wrote a number of pieces for guitar and piano. One biographer has suggested that he may have used his guitars for composing when he didn't have enough money to own a piano.

As for Franklin, he sometimes moonlighted as a guitar teacher, teaching Philadelphia ladies how to play the instrument. He offered to teach one

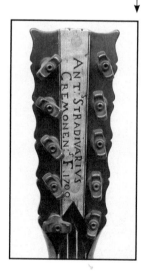

This Stradivarius guitar was made in 1700. It features five sets of double strings instead of the six single strings that are more common today.

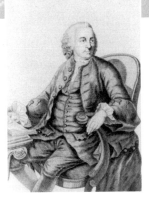
Franklin.

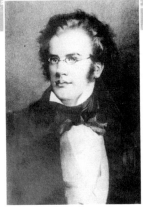
Schubert.

Stradivari.

woman who, according to her son, was "too bashful to become his pupil" and then regretted it her whole life. Franklin also played harp and harmonica. Was there anything he couldn't do?

Franklin, Schubert, and Stradivari. Guitar heroes of an earlier age.

The guitar was introduced to England around 1750. Played mainly by upper-class women, it grew so popular that some commentators feared that this "trifling" and "vulgar" instrument was supplanting the harpsichord. Across the ocean, Mrs. Thomas Jefferson and Mrs. Andrew Jackson were among the many women who learned to play guitar.

BUT FOR A BUTTON

Saving the Messiah

On a Friday evening in Hamburg, December 5, 1704, a boisterous crowd gathered around two angry young men dueling with swords in the bustling marketplace. One was a composer and music critic of some renown named Johann Mattheson. The other was a hotheaded nineteen-year-old who played second violin (and occasionally harpsichord) for the local opera company.

His name was George Frideric Handel.

The two friends had become increasingly irritated with each other. The breaking point seems utterly ridiculous in retrospect: a silly argument over who should be sitting at the harpsichord during the finale of Mattheson's opera *Cleopatra.* That led to a fistfight right in front of the audience, and that in turn led to the duel.

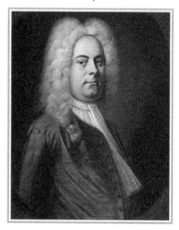

Egged on by the crowd, Mattheson saw his opening and lunged at Handel with his rapier. But instead of delivering a mortal wound, his blade caught on a large metal button and snapped in two. "No harm came of the encounter," said Mattheson, "and we were soon reconciled again."

A fortunate outcome for music lovers.

Handel went on to become a fabulously successful composer in England. But by 1741 he was depressed and bankrupt, his music no longer in vogue. The future king of Prussia wrote to a friend: "Handel's great days are over, his inspiration is exhausted." The fifty-six-year-old composer was suffering

from rheumatism and the effects of a recent stroke. It was at this point that he wrote what would become his best-known work, *Messiah*, in just three short weeks, finishing it, appropriately enough, on a Sunday.

Every Christmas, the "Hallelujah Chorus" from Handel's *Messiah* is performed by all manner of choirs around the globe. Millions have thrilled to its thunderously triumphant strains. But for a button, it never would have come to pass.

> ❝ **A PIECE OF FOLLY WHICH MIGHT HAVE TURNED OUT DISASTROUSLY FOR BOTH OF US.** ❞
>
> —JOHANN MATTHESON

At the London premiere of Messiah, *in 1743, the audience rose during the "Hallelujah Chorus," and stayed standing until the end of the show. Since King George II (left) was in attendance, it has been suggested that the king may have risen first, with the rest of the audience following out of respect. Many theories have been put forward to explain this, including the suggestion that the partially deaf king might have thought he heard the strains of the national anthem. In any case, audiences have been standing for the "Hallelujah Chorus" ever since.*

GIVE THE DEVIL HIS DUE

And now, live from hell . . .

Classical music is filled with pieces written in praise of God. But there is only one composed by a musician who said he was directly inspired by the devil.

Giuseppe Tartini was a famous Italian composer and violinist in the 1700s. One night he dreamed that he had sold his soul to the devil, who then attended to his every need. In the dream, he offered the devil his violin to see what kind of musician he was. "To my great astonishment, I heard him play a solo, so singularly beautiful . . . that it surpassed all the music I had ever heard."

Upon waking, Tartini instantly seized his violin in hopes of capturing the song he had just heard. He gathered up the parts he could remember and fashioned them into his Violin Sonata in G Minor. Or, as it is often called, "The Devil's Trill."

Even today it is regarded as one of the most challenging pieces to play on the violin. Tartini considered it the best thing he ever wrote. And yet, he said, it was nothing compared with the song the devil played in his dream. "It sinks so much into insignificance compared with what I heard, that I would have broken my instrument and abandoned music altogether had I possessed any other means of subsistence."

Nineteenth-century violinist Niccolò Paganini was widely rumored to have sold his soul to the devil. The church refused to allow his burial in consecrated ground, finally allowing it some five years after his death.

Tartini supposedly hung a copy of the manuscript over his door to ward off future visits from Satan. But over the centuries, the violin has never been able to completely escape the hellish reputation Tartini gave it as the devil's instrument.

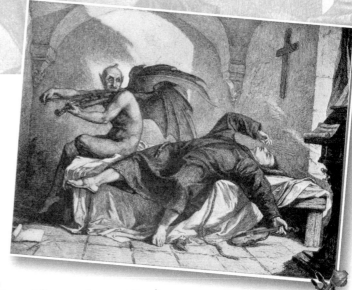

"The Devil's Trill" is not to be confused with what is known as diabolus in musica, *"the devil in music," a medieval name for an interval (known today as a tritone) famous for its dissonant sound. For centuries, the Roman Catholic Church discouraged its use.*

Scottish puritans associated the fiddle with the devil, possibly because of its close association with dancing. That belief traveled to America, where southern fiddlers sometimes called it "the devil's box." A wide array of fiddle tunes sport titles featuring the devil, including "Devil's Dream," "Devil in the Woodpile," "Devil's Reel," and "Devil in the Kitchen."

Fiddler Charlie Daniels had a huge 1979 hit with the song "The Devil Went Down to Georgia," about a fiddle contest between Satan and a Georgia boy named Johnny for a fiddle made of gold.

ONSTAGE AT THE COFFEEHOUSE

Bach's bravo to the bean

It's hard to imagine today just how controversial coffee was when first introduced to Europe. "Base, black, thick, nasty, bitter, stinking nauseous puddle water" a women's petition against coffee called it in 1674. Coffee was considered suspect because of its addictive nature, and because it was an expensive foreign import. Some doctors believed it would make women sterile. The king of England tried to ban coffeehouses in 1686 because he thought they were "the great resort of the idle and disaffected," and many other European leaders felt the same way.

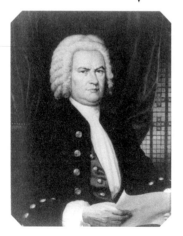

Nonetheless, coffeehouses thrived. Gottfried Zimmerman opened one in Leipzig, and it was here that a group of musicians gathered every Friday night in the 1730s for an informal jam session, public invited. The leader of this group was a man who today is considered one of the towering figures of classical music.

Johann Sebastian Bach.

Most of Bach's music is *very* religious and *very* serious. But the good-time atmosphere of the coffeehouse inspired him to write a piece that is neither. His "Coffee Cantata" is a comedic mini-opera about a desperate father trying to convince his daughter to give up coffee. She refuses his entreaties with words any modern coffee addict could appreciate: "If I can't drink my bowl of coffee three times daily, then in my torment, I will shrivel up like a piece of roast goat."

The "Coffee Cantata" pokes gentle fun at those who would try in vain to prohibit coffee drinking. In the end, the girl tells her father she'll swear off the drink, but secretly tells her suitors they must let her continue.

Johann understood the power of joe.

Some also view Bach's cantata as a political piece, advocating that women should have the same rights as men (at least as far as going to coffeehouses).

One leader who failed to heed the lessons of the "Coffee Cantata" was King Frederick the Great of Prussia. In 1777, Frederick issued rules to restrict coffee drinking, even hiring a corps of sniffers to smoke out stockpiles of roasted coffee beans. He issued this explanation to his subjects:

> *It is disgusting to notice the increase in the quantity of coffee used by my subjects, and the amount of money that goes out of the country in consequence. Everybody is using coffee. If possible, this must be prevented. My people must drink beer. Many battles have been fought and won by soldiers nourished on beer; and the king does not believe that coffee-drinking soldiers can be depended upon to endure hardship or to beat his enemies.*

Frederick's coffee proscriptions were repealed after his death in 1786.

SHEAR MADNESS

The cutting edge of opera

They were the rock stars of their day. Recruited by agents at a tender young age, the same way athletes are today, they were offered financial support, musical training, and a chance to grab the brass ring of fame and riches. Those who succeeded achieved international stardom, money beyond their imaginings, and retinues of swooning fans. But they paid an almost unimaginable price for their sensational success.

Castration.

These were the *castrati,* boy opera singers who were castrated before reaching puberty to preserve their exquisite high voices. They could combine the high tones of women with the lung power of men. The custom began in the 1500s, an era when women were banned from the opera. By some accounts, as many as four thousand boys a year were surgically neutered for this purpose, although of course only a few became superstars. Between 1650 and 1750, hardly an opera was performed in Europe that didn't have at least one *castrato.* The most famous were in such high demand that they could insist that their favorite aria be inserted in the opera they were performing.

The most famous castrato was Carlo Broschi, known all over Europe as Farinelli. He took London by storm when he arrived there in 1734. One titled woman famously cried out "One God, one Farinelli!" at one of his concerts. He eventually retired from the opera and found a place in the Spanish Court, where he performed for King Philip V every night to relieve his depression.

The amazing performances of the *castrati* helped make opera wildly popular. But by the late 1700s, the barbaric custom fell into disfavor with opera fans, and it slowly died out. *Castrati* remained popular in some church choirs until the dawn of the twentieth century.

> Parents of young prodigies often agreed to castration because they saw it as a ticket out of poverty for a child they had no means to support.

The last known castrato, *Alessandro Moreschi, sang in a Vatican church choir until 1913. He made several gramophone recordings that allow modern ears to hear what Renaissance Europe adored.*

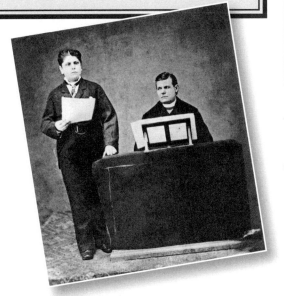

SALVATION SERENADE

The story of a slave trader who left us an amazing legacy

John Newton started in the slave trade at age twenty. He eventually became captain of his own slave ship. "I was once an active instrument in a business at which my heart now shudders," he wrote.

On May 10, 1748, his ship was foundering in a storm. Until then, Newton had never been a religious man, but as the storm threatened to capsize the ship, he fell to his knees and began to pray. "God have mercy," he begged, as wave after wave crashed violently over the deck. When the storm suddenly died down, he vowed to devote himself to God.

That moment changed his life forever. One day it would touch the lives of millions.

It took years, but driven by his new faith, Newton left the slave trade and became a minister. Eventually he started to speak out against slavery, and he turned into a crusading abolitionist.

He also became well known for writing hymns. One song that we remember particularly well today celebrated his own *amazing* transformation.

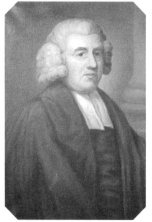

> *Amazing Grace, how sweet the sound,*
> *That saved a wretch like me.*
> *I once was lost, but now am found,*
> *Was blind, but now I see.*

Newton was at first rejected for ordination to the ministry because of his checkered past. He was eventually ordained in 1764, and continued in the ministry for forty-three years. He lived long enough to see the slave trade abolished by the British Empire in 1807.

TO BE SOLD, on board the
Ship *Bance-Yland*, on tuesday the 6th
f *May* next, at *Ashley-Ferry*, a choice

TO BE SOLD, on board the
Ship *Bance-Island*, on tuesday the 6th
of *May* next, at *Ashley-Ferry*; a choice
cargo of about 250 fine healthy

NEGROES,

just arrived from the
Windward & Rice Coast.
—The utmost care has
already been taken, and
shall be continued, to keep them free from
the least danger of being infected with the
SMALL-POX, no boat having been on
board, and all other communication with
people from *Charles-Town* prevented.
Austin, Laurens, & Appleby.

N. B. Full one Half of the above Negroes have had the
SMALL-POX in their own Country.

*Newton continued in the slave trade for
five years after his conversion, finding
it disagreeable, but not yet considering
it morally wrong. "What I did, I did
ignorantly," he said later.*

> ❝ **I AWAITED WITH FEAR AND
> IMPATIENCE TO RECEIVE MY
> INEVITABLE DOOM.** ❞

—JOHN NEWTON DESCRIBING THE STORM

A DANDY TALE

A soldier's song that made history by switching sides

During the French and Indian War, a British surgeon named Richard Shuckburgh put pen to paper to write some new words to an old folk tune. Shuckburgh had the reputation for being a delicious wit. Soon his lyrics, which ridiculed colonial militiamen fighting alongside British soldiers, were on everybody's lips.

"Yankee Doodle Dandy."

In the years leading up to the American Revolution, this song of insult became a favorite of British soldiers serving in North America. They dreamed up countless new verses mocking the colonials they were coming to detest, as a way of putting those uncouth Americans in their place.

On April 19, 1775, as British troops marched out from Boston to Lexington and Concord, fife and drum played the song while soldiers sang merrily along. Later in the day as they found themselves in a desperate battle with an army of rebels, the song could be heard again.

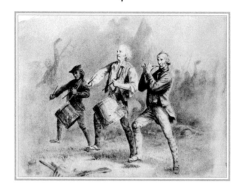

But this time it was the colonials who were singing it, throwing the insulting tune back in the face of the retreating British troops. "Damn them," said one British officer later, "they made us dance it 'til we were tired." After that it never sounded as sweet to British ears again.

Colonists claimed it as their own, sometimes referring to it now as the "Lexington March," and taking a new delight in the self-mocking words. The song came to

haunt the British, who had to listen to it being played when they surrendered at Saratoga and Yorktown.

And that's how the ditty written to ridicule became a patriotic air.

The origin of the word "Yankee" is disputed, but the most likely explanation is that it is from the Dutch word for Johnnie, "Jancke" (pronounced Yankee), used by Dutch colonists in New Amsterdam as a dismissive word for English residents of New England.

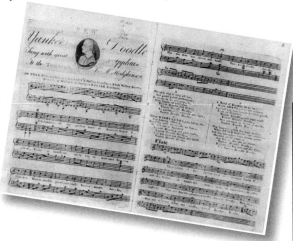

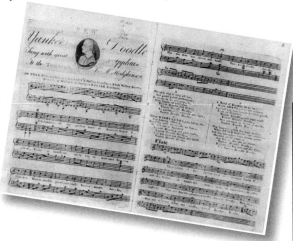
Macaroni

Yankee Doodle came to town
Riding on a pony,
Stuck a feather in his hat,
And called him Macaroni.

Dozens, if not hundreds, of verses were written for the song in colonial times. These lines, among the earliest, refer to a class of foppish dandies in London who wore outlandish clothes and tried to throw around Italian phrases to show how cultured they were. They were called "Macaronies."

> ❝ **IT WAS NOT A LITTLE MORTIFYING TO HEAR THEM PLAY THIS TUNE, WHEN THEIR ARMY MARCHED DOWN TO OUR SURRENDER.** ❞

—BRITISH OFFICER TOM ANBURY, FOLLOWING THE BRITISH SURRENDER AT SARATOGA

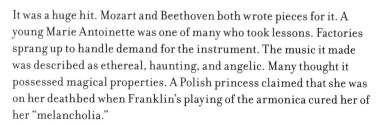

MUSICAL MYSTERY TOUR

From a founding father, music to drive you crazy

Benjamin Franklin's most interesting invention may have been a musical instrument reputed both to heal the sick and to drive the healthy insane.

In 1761, while serving as colonial Pennsylvania's representative in London, Franklin attended a concert where a musician performed with a table full of wineglasses, rubbing his moistened fingers on their rims. The concert inspired Franklin to create a single musical instrument that could duplicate the wonderful tones he heard. Working with a glassblower, he attached thirty-seven glass bowls to a spindle. Each was ground to a different thickness to make a particular note. The player pumped a foot pedal to rotate the bowls, using both hands to play.

Franklin called it the "armonica."

It was a huge hit. Mozart and Beethoven both wrote pieces for it. A young Marie Antoinette was one of many who took lessons. Factories sprang up to handle demand for the instrument. The music it made was described as ethereal, haunting, and angelic. Many thought it possessed magical properties. A Polish princess claimed that she was on her deathbed when Franklin's playing of the armonica cured her of her "melancholia."

But it soon developed a darker reputation. People came to believe that it could cause insanity or wake the dead. A 1788 manual for the instrument warned of its effect on people's temperament. Ten years

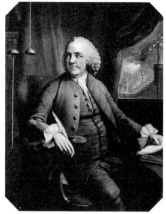

Ben Franklin.

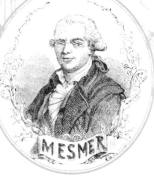

MESMER

later another writer called it "damaging to the health" and "an apt method for slow self-annihilation." The instrument was reported to cause convulsions in dogs and cats. It was banned in some parts of Germany because police believed it posed a public danger.

By the early 1800s, people had turned against the armonica. Franklin's musical instrument disappeared—killed by the myth of its own musical magic.

> ## ITS TONES ARE INCOMPARABLY SWEET BEYOND THOSE OF ANY OTHER.
>
> —BENJAMIN FRANKLIN, DESCRIBING HIS NEW INSTRUMENT IN 1762

Some historians believe that lead in the glass bowls may have slowly poisoned players, creating the armonica's dark reputation. But many who gained fame playing the instrument, including Franklin himself, lived to a ripe old age.

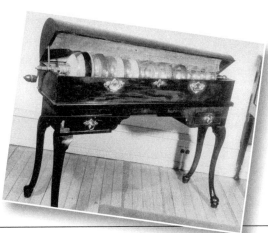

Seventeen-year-old Wolfgang Mozart was introduced to the armonica in the parlor of a controversial Viennese doctor named Franz Anton Mesmer. Dr. Mesmer's interest in "animal magnetism" led him to practice an early form of hypnosis that became known as mesmerism. He often played the armonica to stimulate his patients. On one occasion, a witness wrote that as soon as Mesmer started to play, "my friend was affected emotionally, trembled, lost his breath, changed color, and felt pulled toward the floor." Mesmer eventually came to be regarded as a charlatan and fell out of popular favor—possibly one reason the armonica did the same thing.

PLAYING IT BY EAR

A unique display of Mozart's genius

Mozart was the greatest child prodigy of his age, perhaps any age. He mastered the keyboard at four, and the violin at six, and he was composing concertos at age eight. His virtuosity astounded audiences across Europe. But his most impressive feat had nothing to do with composing or even performing.

It had to do with *listening*.

During Easter week of 1770, Mozart and his father arrived in Rome and hurried to the Sistine Chapel to hear the papal choir perform the "Miserere mei, Deus." (That's Latin for "Have Mercy on Me, God.") They were taking advantage of a rare opportunity.

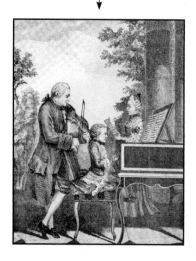

Written by Gregorio Allegri, the "Miserere" was performed only that one week of the entire year, and only in the Sistine Chapel. Its soaring vocals were considered to be uniquely mysterious and spiritual, and the Vatican considered the music close to sacred. Only three copies were known to exist, and it was forbidden on pain of excommunication to copy or publish them.

Mozart captured not just the music as Allegri had written it, but also the so-called abbellimenti, *the embellishments never written down, but passed on from singer to singer in the choir. They were a big part of what made the piece so famously powerful. Some time later Mozart had a chance to perform his version of the piece for Cristoforo, the principal soprano of the papal choir, who declared it perfect.*

That night, the fourteen-year-old Mozart wrote out the entire piece. *From memory.* It was a complex work with nine voices, sometimes singing together, sometimes in counterpoint, and he had never heard it before. Nevertheless, after one listening, he managed to untwine the different voices and get every note down on paper.

Wanting to see if his copy was correct, he hid the score in his hat and attended again the next day. Astoundingly, the piece needed only minor corrections.

Word got back to the pope about what Mozart had done. Instead of being excommunicated, he was praised for his brilliance. After all, he wasn't just anybody—he was Mozart!

Just a year later, the "Miserere" was published in London, and the secret was out. But most scholars don't think that version came from Mozart's copy. "As it is one of the secrets of Rome," Mozart's father, Leopold, had written to his wife, "we do not wish to let it fall into other hands."

NATIONAL TREASURE

The founding father

of American music

William Billings had a withered arm, a gimpy leg, a blind eye, and a raspy voice. A tanner by trade, he was slovenly in appearance and inhaled snuff (a form of smokeless tobacco) at an alarming rate. He was also America's first prominent composer. A largely self-taught musician, he published the first book of American music and wrote the song that became the unofficial national anthem during the American Revolution.

His earliest compositions were chalked on the wall of his tannery. In 1770, at age twenty-four, he published *The New England Psalm Singer,* the first book of songs written by an American. His friend Paul Revere engraved the cover. Billings was such an ardent patriot that he delayed publication of the book for a year until he could print it on paper made in the colonies.

His song "Chester" became a popular patriotic anthem sung by colonial soldiers during the American Revolution.

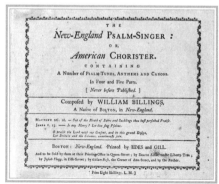

Let tyrants shake their iron rod,
And Slav'ry clank her galling chains,
We fear them not, we trust in God,
New England's God forever reigns.

Largely forgotten today, Billings's music was so popular in the 1780s that one critic called him a "rival of Handel." But not everyone was a fan. Pranksters hung two cats by their tails from a signpost outside his house, comparing the cats' cries to his music.

Billings was also a musical revolutionary who didn't believe in old rules and tried to inject a new vitality into American church music. He pioneered use of the pitch pipe to keep choral groups in key, and he was daring in his use of the organ at a time when most church leaders in America opposed using musical instruments in church music.

William Billings: an American original.

> ❝ FOR MY OWN PART, AS I DON'T THINK MYSELF CONFINED TO ANY RULES OF COMPOSITION, LAID DOWN BY ANY THAT WENT BEFORE ME . . . I THINK IT BEST FOR EVERY COMPOSER TO BE HIS OWN CARVER. ❞
>
> —WILLIAM BILLINGS, FROM *THE NEW ENGLAND PSALM SINGER*

Billings's book, featuring this illustration by his fellow patriot Paul Revere, wasn't just a collection of songs. It was a comprehensive musical manual with information on pitch, harmony, tempo, musical notation, rules for using the voice, and even an essay on the nature of sound.

1781

THE QUEEN AND THE DITTY

Nobody can deny Marie Antoinette's role in making this obscure lullaby a big hit

The queen had a baby. The baby had a nurse. The nurse had a song. She would sing the baby to sleep with it every night. It was a silly old song making fun of an English general named Marlborough. "Marlbrough s'en va-t-en guerre" ("Marlborough has left for the war"). A song that only a few people in the distant provinces even remembered.

The queen, Marie Antoinette, was from Vienna. She had never heard the little ditty, but now found herself enchanted by it. She began to sing it too. Soon the king was singing it as well. Not long afterward it was on the lips of everyone at their court in Versailles. By 1783, it was all the rage in Paris. It was written into plays and comedy shows. The words appeared on fans and scarves. Visitors to France wrote with frustration about how you couldn't escape hearing it.

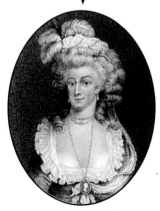

Its popularity spread across the water to England as well, and to the United States, where it remains one of the most popular songs of all time.

You say you don't know it? Sure you do. But probably with another set of lyrics, written in the early 1800s by an anonymous Englishman for the tune Marie Antoinette had turned into a global phenomenon.

"For He's a Jolly Good Fellow."

The song was so firmly associated with France in the early 1800s that when Beethoven wrote a piece about Wellington's victory over Napoleon at the Battle of Waterloo, he used some of the tune to represent the French military marching to battle.

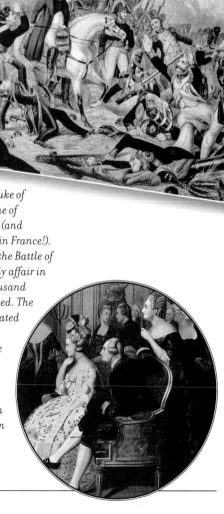

The song is about the first duke of Marlborough, considered one of England's greatest generals (and therefore not exactly a hero in France!). It was written shortly after the Battle of Malplaquet in 1709, a bloody affair in which more than thirty thousand people were killed or wounded. The lyrics tell how news of the hated British commander's death was brought back to his wife in England, though in fact Marlborough was not killed in the battle. Some scholars believe it is based on a much older tune brought back from the Middle East during the Crusades.

THOSE WERE THE DAYS

*The tale behind
the tradition*

Every year on New Year's Eve, as the clock strikes midnight, we celebrate a chance meeting in Scotland that took place more than two hundred years ago.

Robert Burns was a poet, a fiddler, and a passionate collector of Scottish folk tunes. One day he happened to hear an old man singing a bit of a song that he had never heard before. "A glorious fragment," he called it, written by a "heaven-inspired poet."

Burns scribbled down the words, including the title, an old Scots phrase that was already falling out of use even then: "Auld Lang Syne." Loosely translated, it means "days gone by." Then he added some verses of his own and set the whole thing to an old Scottish tune.

The song wasn't published until after his death, but it quickly became his best known. Today it is popular the world over. The melody is frequently played at funerals and graduations in Taiwan. Crowds in Thailand sing it after sports matches. In Japan it is often played at the end of the business day to tell customers that the store is closing.

Burns is regarded as the national poet of Scotland. But his most famous work is one that he freely admitted didn't originate with him at all.

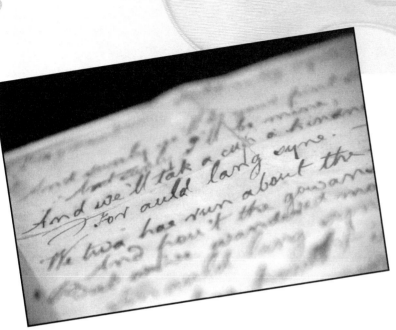

Burns's original manuscript, dated 1788. He called it "an old song of the olden times." Musicologists have found the phrases "Should auld acquaintance be forgot" and "auld lang syne" in a Scottish poem dating back to the 1600s.

The tradition of singing "Auld Lang Syne" on New Year's Eve is sometimes attributed to bandleader Guy Lombardo, but in truth it dates back to at least the 1890s in the United States, and even earlier in Scotland.

I WILL SURVIVE

*From disaster
to dynasty*

Heinrich was the last of twelve children, born in 1797 to a humble forester and his wife in a small German mountain town. His youth was, in a word, catastrophic. Europe was engulfed in war. His father and several older brothers went off to fight, while his mother fled higher up in the mountains with the younger children to escape French invaders. Conditions were unspeakably harsh.

Only Heinrich and one sister survived.

When his father and two surviving brothers returned from the war, Heinrich went to work with them repairing roads and planting trees. In 1812, a fast-moving storm took them by surprise. They took shelter in a primitive hut, but a freak lightning strike killed everyone inside, except fifteen-year-old Heinrich. He had to crawl over the bodies of his father and brothers to get out. He joined the Prussian army as a bugler and ended up at the Battle of Waterloo—somehow surviving the carnage that cut down more than forty thousand on that field of battle.

Things eventually got better—how could they not? He learned woodworking and took up cabinetmaking. He fell in love, got engaged. And in 1825, he gave his new wife, Julianne, a wedding present he had carefully crafted with his own hands.

A piano.

One of Steinway's piano innovations was "overstringing" . . . fanning out the base strings over the treble strings so that they could be longer. This allowed for greater resonance and clarity.

It was the first piano he ever made, but it wouldn't be the last. It is amazing Heinrich made it to adulthood, a thousand-to-one shot. But once he did, he channeled that willpower into unsurpassed craftsmanship. He eventually moved to the United States, where the Americanized version of his name would become synonymous with excellence in piano making.

Steinway.

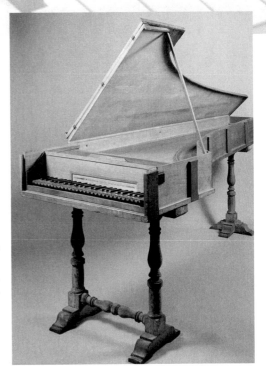

The piano (or pianoforte, as it was known) was invented by Bartolomeo Cristofori around 1700. This is one of the pianos he built. Piano is Italian for plain, forte *means strong— unlike the harpsichord, this new instrument could play at softer or louder levels, depending on how the keys were struck.*

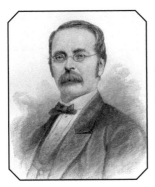

After moving to the United States to escape revolution in Germany, Steinway and his three sons founded their famous piano company in 1853. They made just nine pianos that year, but word got around. Within ten years they had built the largest piano factory in the world to keep up with demand.

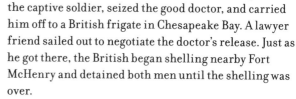

"THE STAR-SPANGLED BANNER"

Please rise . . .

and tip your hat

to the drunken

redcoats who

made it possible

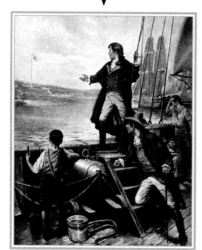

Washington, D.C., was aflame, thanks to British soldiers who had put it to the torch. With smoke still rising from the ruins, the Brits set out on a march through Maryland. After most of the soldiers had filed peacefully through the town of Upper Marlboro, two drunken stragglers came along shouting and carrying on. One of the town fathers, Dr. William Beanes, was so incensed with this behavior that he personally carted the drunken redcoats to jail.

But one of the men escaped and brought back more redcoats. They released the captive soldier, seized the good doctor, and carried him off to a British frigate in Chesapeake Bay. A lawyer friend sailed out to negotiate the doctor's release. Just as he got there, the British began shelling nearby Fort McHenry and detained both men until the shelling was over.

And that's how a lawyer named Francis Scott Key happened to observe the flag over the fort still standing amid the "rockets' red glare." His poem "The Star-Spangled Banner" (originally titled "Defence of Fort McHenry") became an instant hit.

The music? Key purloined it from a tune called "To Anacreon in Heaven," which, appropriately enough, was a popular English drinking song.

Key wrote the poem in a Baltimore hotel room the day after the battle. It was published for the first time less than a week later.

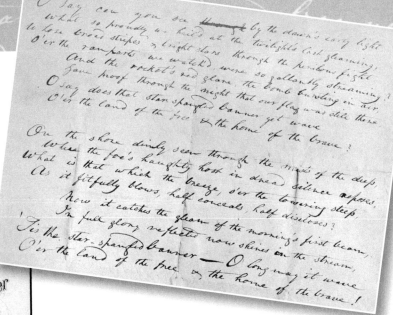

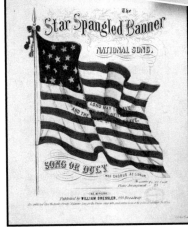

Although it was unofficially considered the national song of the United States for more than a century, it wasn't until 1931 that it was officially adopted as the national anthem.

AN AMERICAN ARMY OF TWO

How a pair of teenage girls outwitted a British man-of-war

In June of 1814, the British frigate HMS *Bulwark*, seventy-four guns, raided the Massachusetts town of Scituate, setting fire to six ships in the harbor. The town promptly formed a militia company to protect itself. The men held their drills by the lighthouse overlooking the harbor, but as the summer went by without any more incidents, they let their guard down.

In September, the *Bulwark* came back for another bite.

Rebecca Bates, the eighteen-year-old daughter of the lighthouse keeper, spotted the British ship sitting offshore. A rowboat full of soldiers was setting off toward the harbor, where two fully loaded merchant ships presented a juicy target.

Her father wasn't around. There was no time to get to town to warn of the attack. Then Rebecca noticed something the militiamen had left at the lighthouse, something that gave her an idea.

A fife and a drum.

The soldiers had taught Rebecca and her sister a few songs over the summer. Now Rebecca thought they could use one of them to fool the British. "Keep out of sight," she warned her sister. "If they see us, they'll laugh us to scorn." The two girls hid out behind a dune and played "Yankee Doodle" for all it was worth.

Rebecca Bates lived to a great old age and told many people of the day she saved Scituate. She and her sister even signed affidavits swearing to their story.

The British heard the all-too-familiar tune wafting over the water. It could mean only one thing: American soldiers were gathering to repel their attack. A signal pennant was hoisted, and the raiding party aborted their mission.

Scituate was saved from attack by Rebecca and Abigail Bates, forever known to their town as An American Army of Two.

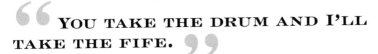

" YOU TAKE THE DRUM AND I'LL TAKE THE FIFE. "

— REBECCA BATES TO HER SISTER ABIGAIL, AS THEY PLOTTED
TO DRIVE OFF THE BRITISH

Rebecca and her sister playing their tune.

MEASURE FOR MEASURE

*A night to remember
with Ludwig
van Beethoven*

Beethoven's Ninth Symphony is regarded as one of the greatest pieces of music ever written. Picture the scene at the premiere performance inside Vienna's Kärntnertortheater. It was a Friday night, May 7, 1824. The anticipation was intense: Beethoven hadn't appeared onstage in twelve years.

"He stood before the lectern and gesticulated furiously," said violinist Joseph Bohm. "At times he rose, at other times he shrank to the ground; he moved as if he wanted to play all the instruments himself."

But the musicians all ignored him.

Not out of rudeness, but out of prudence. Beethoven had started going deaf in his twenties. Now at age fifty-four, his hearing was gone. He could not hear the orchestra playing the music he had written. Concertmaster Michael Umlauf quietly spoke to all the players and singers beforehand, asking them to follow his baton only, and not the timekeeping of the composer.

By the end of the piece, Beethoven was a few measures behind. The musicians had stopped playing, but he was still keeping tempo and leafing through the pages of the score as if to find his place. That's when singer Caroline Unger performed one of the most endearing acts in music history. The contralto walked up to the old master and gently turned him around, so he could see what he could not hear:

A jubilant audience exploding in applause and cheers over the extraordinary piece that they had just heard but Beethoven never could.

Caroline Unger was a twenty-year-old contralto at the time of the concert. Over the next twenty years she performed all over Europe, and a number of operas were written especially for her to sing.

> The greatness of Beethoven's Ninth wasn't immediately apparent to everyone. One reviewer in London wrote: "We find Beethoven's Ninth Symphony to be precisely one hour and five minutes long; a fearful period indeed, which puts the muscles and lungs of the band, and the patience of the audience, to a severe test."

The audience at the premiere gave Beethoven five standing ovations. He is said to have fainted afterward and refused food or drink until the next day.

SOMETHING ABOUT MARY

Is someone trying to pull the wool over our eyes?

For such a simple little ditty, "Mary Had a Little Lamb" sure has a complicated and controversial history. Even Henry Ford and Thomas Edison managed to get into the act.

It first appeared as a poem of six stanzas in the 1830 book *Poems for Our Children*. The author was Sarah Josepha Buell Hale of Boston, a novelist, poet, magazine editor, and activist who was one of the most impressive American women of the nineteenth century.

But wait!

Mary Elizabeth Sawyer of Sterling, Massachusetts, declared that she was the Mary of the story, and that someone else wrote the poem—or at least the first three verses. Sawyer said she nursed the lamb to health after it was born small and sickly. When it followed her to school one day in 1817, she and her brother Nate snuck it into the schoolhouse. But when teacher Polly Kimball called on her, the lamb followed her to the front of the class. Uproar ensued. A young man named John Roulstone, who was visiting the school that day, was so amused that he dashed off the poem and gave it to Mary.

Henry Ford was so convinced by Mary Sawyer's story that he paid to move the one-room schoolhouse in Sterling, Massachusetts, to the grounds of the Wayside Inn in nearby Sudbury to make sure it was preserved. Hearing of Ford's interest in the story, Thomas Edison revealed that one of his earliest test recordings on the phonograph was "Mary Had a Little Lamb." Edison even made a new recording reenacting his earlier version.

Could Mary's version be true? All the people she named really existed, and she stuck to her story into old age. Family members backed her up, and many others have believed her, too, including Henry Ford. He was fascinated by the tale and published a book about the origins of the song during the 1920s.

Some scholars have suggested that maybe Hale heard some version of Roulstone's poem, then enlarged and improved upon it—a common practice at the time. But chances are that we will never know for sure the truth about Mary.

THERE WAS A CLATTER, CLATTER ON THE FLOOR, AND I KNEW IT WAS THE PATTERING OF THE HOOVES OF MY LAMB. OH HOW MORTIFIED I FELT!

—MARY ELIZABETH SAWYER, DESCRIBING THE MOMENT THE LAMB FOLLOWED HER TO THE FRONT OF THE CLASS

Among her many other accomplishments, Sarah Hale is responsible for getting Thanksgiving proclaimed a national holiday. She campaigned for more than fifteen years and lobbied five presidents.

"Mary Had a Little Lamb" was set to music by a rather distinguished musician, Dr. Lowell Mason. He was the first person to introduce music education into public schools in the United States. Mason had asked Hale and others to write verses suitable for young children that he could turn into songs.

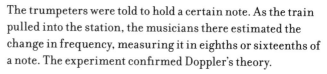

SCIENCE IN THE KEY OF C

*Of trumpets,
railroads, and
musical
experimentation*

Oh, to be an innocent bystander alongside the tracks of the Rhine railroad in the Netherlands that day in 1842. Along came a train with an open car full of trumpeters blowing for everything they were worth. Another group of musicians could be seen on the platform of the train station, ears cocked, furiously scribbling down notes as the train pulled in. What in heaven's name was going on?

It was an ingenious experiment conducted by Dutch scientist Diederik Buys Ballot to test a brand-new theory proposed by Austrian scientist Christian Doppler.

Doppler was the first to theorize that light waves and sound waves appear to change in frequency if the source is moving toward or away from the observer. He suggested a formula for calculating what the change should be. Buys Ballot set out to test the idea.

The trumpeters were told to hold a certain note. As the train pulled into the station, the musicians there estimated the change in frequency, measuring it in eighths or sixteenths of a note. The experiment confirmed Doppler's theory.

Also known for his work in meteorology, Buys Ballot founded the Royal Dutch Meteorological Institute and remained its director until his death in 1890.

The Doppler effect is now a cornerstone of many different fields, including radio astronomy, radar, and medical imaging. The trumpeters on the train car are forgotten, but their song plays on.

We hear the Doppler effect most dramatically when a race car drives by, and the pitch of the sound changes dramatically as it approaches and then passes.

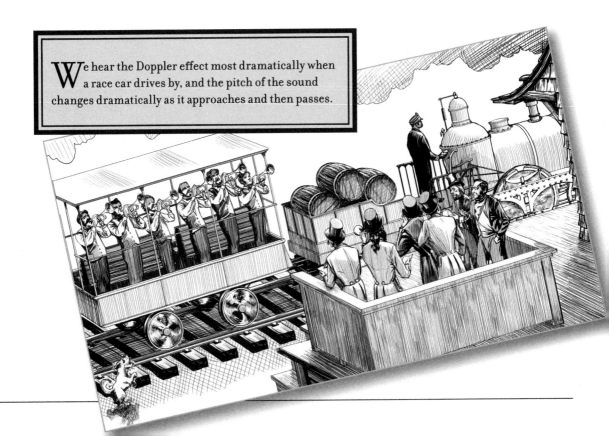

TWIST AND SHOUT

*Driving the fans
wild . . . more than
150 years ago*

Night after night the arenas were filled with thousands of adoring young women who screamed and swooned. They mobbed the stage, frantically trying to snip pieces of the performer's clothing or locks of his long flowing hair to preserve as souvenirs. As the concert tour traveled from city to city, the media reported breathlessly on the mounting hysteria ensuing at each stop.

Nineteen sixties Beatlemania? Hardly. This was 1840s Lisztomania, the mass hysteria created by virtuoso Hungarian pianist Franz Liszt.

His looks were striking, his personality powerful, and his playing intense. One observer called him a "smasher of pianos" because he played so violently that piano strings frequently snapped. His concerts sent audiences into ecstasy. The word "groupie" hadn't been invented yet, but he had plenty. "The paroxysms of his adorers has reached the limit of madness," wrote one reporter.

From 1839 to 1847, Liszt went on the mother of all concert tours, performing more than a thousand dates in 150 cities. He virtually invented the idea of a solo piano concert—in fact, the phrase "piano recital" was coined to describe his 1840 concert in

Liszt retired from the life of a performer in 1847 and devoted himself to composing. Over his lifetime he wrote twelve symphonic poems, two piano concertos, and many solo piano pieces.

London. He was the first to play a program of memorized pieces, and the first to position the piano sideways on the stage for better sound—and a better view of the performer. He won the hearts of fans by giving numerous benefit concerts for worthy causes.

Liszt was the prototype of the performing artist as a celebrity superstar, a force to be reckoned with. Rock on, Franz.

Even hard-bitten music critics found themselves undone by Liszt. After a concert in St. Petersburg, Russian critic Yuri Arnold had this reaction: "As soon as I reached home, I pulled off my coat, flung myself on the sofa, and wept the bitterest, sweetest tears."

The term "Lisztomania" was coined by German journalist and poet Heinrich Heine in 1844. He called it "a veritable insanity." Women would fight over an empty glass Liszt put down, or gather up a thrown-away cigar butt and hide it between their breasts. What would Freud have made of that?

HAIL TO THE WIVES!

The pair of supportive First Ladies who picked a presidential theme song

After the sudden death of President Harrison in 1841, John Tyler became the first vice president to take over the helm. Although some thought he should call himself "Acting President," Tyler promptly moved into the White House and claimed the title and full powers of the office, setting a precedent for later VPs.

The presidency was no picnic for Tyler. People mocked him as "His Accidency." When he vetoed a bill establishing a national bank, almost everyone in his cabinet resigned, his party ejected him, and the first impeachment resolution against a president was introduced in the House.

Tyler's wife died early in his term. Two years later he married a vivacious young woman named Julia Gardiner. After their marriage, they held a series of parties at the White House. The new First Lady, trying to bolster her husband's ego and image, requested that the Marine Corps Band play a stirring song from a popular stage play whenever the president made his entrance at one of the parties.

The name of the song: "Hail to the Chief."

The song happened to be a lifelong favorite of the next First Lady, Sarah Polk. Her husband, President James Polk, did not cut a very dashing figure. In fact, he had a way of entering a crowded room almost unnoticed. To help him appear more impressive, she

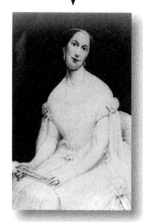

Julia Tyler.

asked that the song be played *every* time he made an entrance.

A tradition was born.

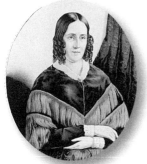

Sarah Polk.

I t wasn't until 1954 that the Defense Department established the song as an official tribute to the president.

John Philip Sousa, conductor of the Marine Corps Band, wrote a replacement for "Hail to the Chief" at the request of President Chester A. Arthur, who hated the song. Sousa, composer of such famous marches as "Stars and Stripes Forever," came up with a song called "Presidential Polonaise." Alas, it wasn't one of his great efforts and failed to make any more of a dent than Arthur's brief presidency.

The music was originally written by an English composer in 1812 to accompany a stage production of Sir Walter Scott's epic poem "The Lady of the Lake." The "Chief" in the song is a Scottish Highlander named Roderick Dhu who is eventually killed by England's King James.

STRAUSS VS. STRAUSS

The King is dead!

Long live the King!

Johann Strauss was known as "The Waltz King." All of Europe seemed to idolize the Viennese violinist and bandleader for the waltzes he wrote and performed. But he definitely didn't want his oldest son to go into the family business.

Johann Strauss the elder wanted Johann Strauss the younger to become something more respectable: a banker or a merchant. When he heard the six-year-old boy play an original waltz on the piano, he forbade him from any other musical activity. With help from his mother, young Johann began taking violin lessons in secret. The father caught his son practicing one day, and whipped the boy, shouting he would beat the music out of him.

He didn't.

At age nineteen, Johann was ready to perform his own compositions in public with an orchestra. His father tried to prevent anyone from hiring him. He ridiculed his son, saying the young man didn't have "the faintest idea" of how to write a waltz. When a concert was arranged, the father's business manager hired thugs to sit in the

At his famous first concert, Johann Strauss the younger ended by playing one of his father's waltzes, bringing tears to the eyes of the audience. While he rebelled against his father's wishes, during his long life he never wrote a word in criticism of his father, and in fact worked to preserve his legacy.

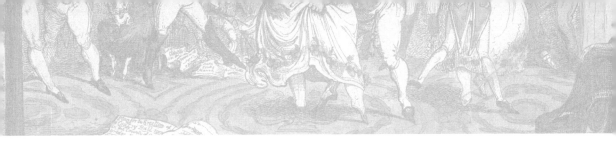

audience and jeer. Everyone in Vienna was caught up in the family quarrel. Thousands crowded around the casino where the concert was to take place. Mounted police had to be called in to control the crowd.

Perhaps the father wanted to spare his son the travails of the music business. Or perhaps he sensed that young Johann might threaten his own fame. If so, he was absolutely right. The concert was a rousing success. The son would go on to write some of the most famous waltzes of all time, including "The Blue Danube" and "Tales from the Vienna Woods," as well as the operetta *Die Fledermaus.*

Vienna had a new Waltz King.

The waltz was considered shocking when it was first introduced. Critics called it "riotous" and "indecent." Nevertheless, it took Europe by storm in the late 1700s. Nowhere was it more popular than in Vienna. A visitor to the city in 1776 wrote: "The people were dancing mad."

SAVED BY A SONG

Melody and manners combine to save a president

President John Tyler was one of hundreds of Washington VIPs crowded aboard the warship *Princeton*. They were there to see a demonstration of the biggest naval gun in the world. Called "The Peacemaker," it had been designed under the supervision of the *Princeton*'s captain, Robert Stockton. Weighing nearly thirteen tons, the cannon could hurl a 228-pound cannonball five miles.

After the fearsome cannon was fired twice, the delighted crowd repaired belowdecks for a sumptuous feast. Toasts were drunk and guests began to break out in impromptu song. Then came the announcement: the big gun would be fired one more time. Many hurried up to the deck to get a good view of it.

President Tyler had his foot on the ladder to climb up to the deck when he heard his son-in-law start to sing a military song. It would be rude to leave in the middle of it, so he paused.

That's what saved his life.

Before the song was done, the cannon fired once again. Catastrophe! The gun's breech exploded, sending jagged junks of hot iron flying into the crowd on the ship's deck. Secretary of State

The Princeton *was designed by Swedish designer John Ericsson, who later designed the famous ironclad* Monitor. *The* Princeton *was the country's first steam-powered naval ship with a propeller instead of a side-wheel.*

Both Abel Upshur and Secretary of the Navy Thomas Gilmer were killed, as were four others.

Among the dead was a friend of Tyler's named David Gardiner. As the fifty-three-year-old president consoled Gardiner's twenty-three-year-old daughter, Julia, in the days following the incident, romance blossomed. The two were married four months later.

A navy board of inquiry exonerated Captain Stockton of any blame for the accident. He went on to command the Pacific Fleet and became the first military governor of California. The city of Stockton, California, is named for him.

President Tyler had another narrow escape after the funeral. Something frightened his carriage horses and they bolted out of control up Pennsylvania Avenue. Near the White House, a man stepped out of the crowd and grabbed the horses, saving the president from possible injury or death.

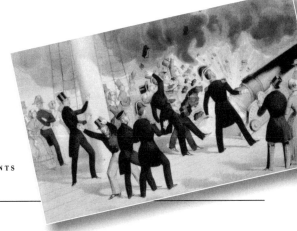

" IT IS INCREDIBLE THAT A JOLLY MILITARY SONG SHOULD HAVE DELIVERED THIS MAN FROM CRIPPLING INJURY OR SUDDEN DEATH. "

—JAMES BIRNEY, ONE OF TYLER'S POLITICAL OPPONENTS

BATTLE OF THE BANDS

*Adolphe Sax blows
his own horn*

It was a musical showdown on the streets of Paris. High noon with a G clef. The upstart young Belgian versus the French traditionalists. "Gentlemen, reach for your instruments."

Adolphe Sax was a young Belgian instrument maker living in Paris who had invented a whole family of horns. He thought French military bands sounded pathetic, and he proposed completely reorganizing them—and equipping them with *his* new instruments. The military brass was indignant, but the French government set up a musical duel to put Sax's idea to the test.

On April 22, 1845, in a park where the Eiffel Tower is today, twenty thousand people showed up to witness the event. Sax was almost done in when seven of his musicians failed to show up—bribed by his enemies to stay away—but he rose to the challenge, playing two different instruments himself to fill in for the missing players. It was a rout—Sax was triumphant, and the talk of Paris.

Adolphe Sax was a man of arrogant self-confidence and fiery temper, who inspired passionate devotion or vitriolic hatred. "In life there are conquerors and the conquered; I most prefer to be among the first." His instrument has also attracted its fair share of controversy, having been attacked by conductors, critics, and even the Catholic Church. In 1925, Washington, D.C. , policewoman Rhoda Milliken spoke for many who have condemned the sax over the years when she said: "Any music played on a saxophone is immoral."

One of the instruments Sax played that day particularly caught the public eye. Its shape was unusual, its sound unlike anything else. "It cries, sighs, and dreams," said French composer Hector Berlioz. Sax hoped it would become a fixture of symphony orchestras. Instead, its sultry sound would become synonymous with smoky nightclubs, cool cats, and hot jazz.

The saxophone.

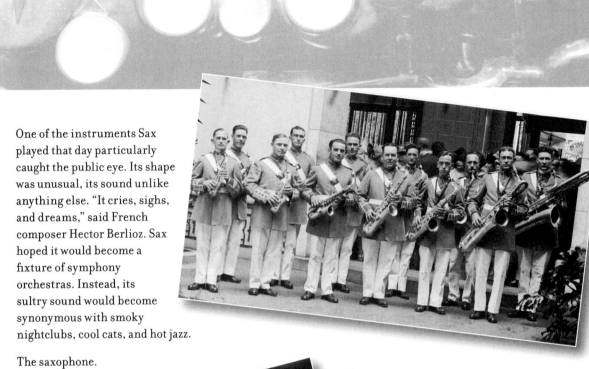

Sax's French competitors did everything they could to undermine the saxophone after he patented it in 1846. They attacked him with lawsuits, bribed his employees, stole his plans, set fire to his factory, and even planted a bomb under his bed. But nothing could keep the saxophone quiet.

WHATEVER LOLA WANTS

The lady behind
the legend

In the Broadway musical *Damn Yankees*, a temptress named Lola proclaims her power over men in the song "Whatever Lola Wants, Lola Gets." Largely forgotten today is the real-life Lola who inspired the alluring stage character.

Lola Montez was one of the most outrageous personalities of the nineteenth century. Born an Irish girl named Marie Gilbert, she reinvented herself as a Spanish dancer. What she lacked in talent she made up in beauty and verve. She took Europe by storm, her seductive "Spider Dance" described by one observer as "no dancing at all, but a physical invitation."

She was famous for her impetuous temper and her wild ways. She danced before the czar in Berlin, but was kicked out of that city after whipping a police officer. Married three times, she collected lovers by the dozen, including King Ludwig of Bavaria and composer Franz Liszt. Wherever she went, scandal was sure to follow. After she convinced King Ludwig to make her a baroness, his cabinet resigned and a mob surrounded her house. She brandished a knife in the window and taunted the crowd. The king was eventually forced to abdicate, and Lola to flee.

Montez was an outrageous liar who constantly concocted new tales about her own life. She told people she had been honored by Queen Victoria, when actually she fled London in disgrace after her identity was revealed. She insisted her whole life that she was the widow of a Spanish lord, even though the truth was widely known.

Crowds flocked to get a glimpse of her when she came to the United States in 1851. Once her dancing days were done, she lectured and wrote books on fashion, gallantry, and beauty. When her life was almost over, she could say with no exaggeration:

"I have known all the world has to give—ALL!"

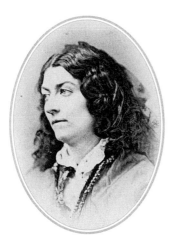

In Damn Yankees, *Lola is summoned by the devil to work her charms on a baseball fan named Joe Hardy. Hardy offers to sell his soul to prevent the Yankees from winning a championship—something many other baseball fans have no doubt considered over the years.*

" **THE MOST PERFECT, MOST ENCHANTING CREATURE I HAVE EVER KNOWN.** "

—FRANZ LISZT, DESCRIBING LOLA MONTEZ

Lola did things that women in her day simply weren't supposed to do—and somehow got away with it. Once she was knocked cold by a chandelier while being carried on the shoulders of half-naked young men in a drunken orgy.

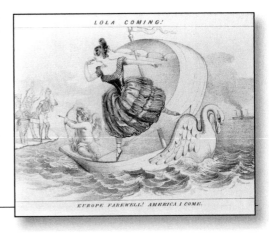

BATTLE OF THE BELLS

Dashing through

the claims

"Jingle Bells" is one of the most recognizable Christmas songs in the world, although it really isn't about Christmas at all. It's about racing fast sleds and picking up pretty girls. Think Beach Boys with snow instead of sand. Some things never change.

Is it possible that this quintessential depiction of winter in New England is a song of the South?

The song was first published in 1857 under the title "A One Horse Open Sleigh." The writer, James Lord Pierpont, was the organist and choir director of a church in Savannah, Georgia. Today, Savannah proudly declares itself the birthplace of "Jingle Bells."

But wait a minute!

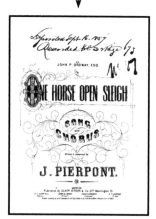

Medford, Massachusetts, says Savannah's claim is just a southern snow job. Medford says the song was written there. Pierpont was a native New Englander who lived in Medford while his father was a minister there. According to local lore, he wrote the song on a boardinghouse piano for a Thanksgiving service at his father's church. Bah, humbug, says Savannah, where's the proof?

Today the question remains: Did Pierpont write the song in Medford, but not copyright it until years later when he was down south? Or did he write it in sunny Savannah, homesick for the winters of Medford?

Oh, what fun it is to fight about a one-horse open sleigh.

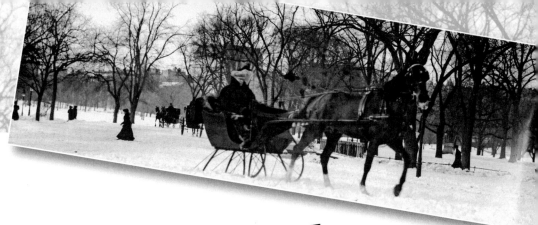

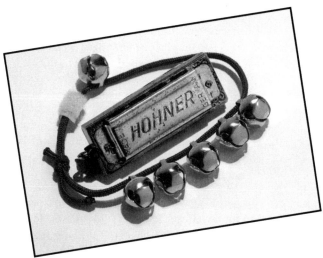

"Jingle Bells" was the first song played live from space. A week before Christmas in 1965, Gemini 6 astronaut Tom Stafford radioed Houston that he had spied an unusual object not far from their spacecraft. As panicked controllers scanned their instruments, Stafford continued: "I see a command module and eight smaller modules in front. The pilot of the command module is wearing a red suit." The next thing that came over the radio was the sound of "Jingle Bells" being played by Wally Schirra on harmonica. That harmonica, with sleigh bells attached, resides today at the Smithsonian's Air and Space Museum.

The son of an abolitionist minister, Pierpont took the side of the South in the Civil War. He served in the Confederate army and wrote several Southern anthems including "Our Battle Flag" and "Strike for the South."

DARING YOUNG MAN

Fashion's most
well-known
swinger

D o these words strike a bell?

He floats through the air with the greatest of ease
The daring young man on the flying trapeze.

The chorus from the old song is familiar to many. But few know that it refers to a real person who revolutionized aerial acrobatics. Today he is better remembered for what he wore than what he did.

His name was Jules, and he made his dramatic debut at a Paris circus in 1859. He was the first aerial acrobat to swing from trapeze to trapeze, doing somersaults in the air, and he became a worldwide sensation. "No mere description can convey an idea of what he does during that intensely exciting half hour," wrote a reporter after his first appearance in London.

When he performed, he wore a skintight one-piece garment of his own invention. It not only allowed for unrestricted movement but showed off the physique that made him such a big hit with adoring female fans.

He called it a *maillot*, but today we know it by another name.

At the Cirque Napoleon in Paris, according to one chronicler, he was outfitted in a costume made of crimson velvet and covered with spangles for his premiere performance. "Take it off," he demanded. "I am not going to play the clown." He wore his own simple outfit instead.

Like Madonna, Jules was one of those performers so famous he was usually known by just a single name. But it wasn't his first name, it was his last:

Leotard.

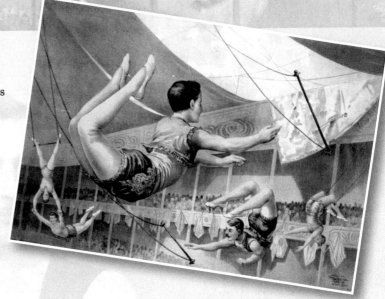

Leotard's father owned a gym in Toulouse, France, and from a young age Jules trained on ropes hung from the ceiling over the swimming pool. The invention of the flying-trapeze act was most likely a family affair.

The song "The Flying Trapeze" was written in 1867 by George Leybourne and Gaston Lyle, and became very popular. It has been recorded by hundreds of performers including Burl Ives, Bruce Springsteen, and Alvin and the Chipmunks.

NOT WHISTLING DIXIE

The most famous song of the South— born and bred in the North

"Dixie," the anthem of the South, was actually written in a New York hotel room by a man from Ohio.

The year was 1859, and composer Daniel Decatur Emmett wrote the song on a rainy Sunday afternoon for Bryant's Minstrels, one of the blackface minstrel shows popular at the time. It proved to be such a hit that other minstrel shows around the country started using it, too.

In 1861, it was played at the inauguration of Jefferson Davis as president of the Confederate States of America. Soon it became the marching song for the Confederate army. "It is marvelous," wrote one Southern soldier, "with what wildfire rapidity this tune 'Dixie' has spread across the whole South."

This was an outrage to Emmett, a staunch Union supporter. "If I'd known to what use they were going to put my song," he reportedly said, "I'll be damned if I'd have written it."

So Emmett, the creator of "Dixie," was actually a damned Yankee!

A contemporary of Stephen Foster, Dan Emmett wrote two other minstrel songs that became American classics, "Jimmy Crack Corn" and "Old Dan Tucker." After the Civil War, he came to cherish the South's love of "Dixie." In 1895, at age eighty, Emmett made a farewell tour and sang the song to standing ovations across the region.

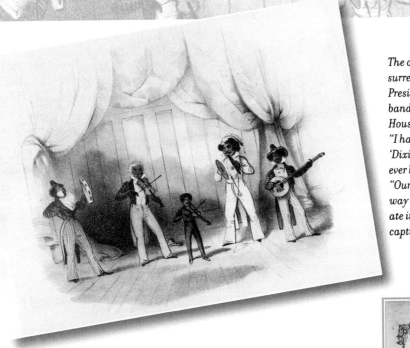

The day after Robert E. Lee surrendered at Appomattox, President Lincoln asked a band outside the White House to strike up "Dixie." "I have always thought 'Dixie' one of the best tunes I ever heard," Lincoln said. "Our adversaries over the way attempted to appropriate it, but we have fairly captured it."

> **IT MADE A TREMENDOUS HIT, AND BEFORE THE END OF THE WEEK EVERYBODY IN NEW YORK WAS WHISTLING IT.**

—DAN EMMETT ON THE FIRST PERFORMANCE OF "DIXIE" IN 1859

ONE-HIT WONDER

The oldest-known piece of recorded music

More than twenty years before Thomas Edison invented the phonograph, Édouard-Léon Scott de Martinville successfully recorded someone singing a song. The reason he didn't become famous for doing so is that he had no way to play it back.

And neither did anyone else—for the next 150 years.

Scott was a Paris printer and librarian who moonlighted as an inventor. In 1857, he patented a device he called the *phonautograph*. It had a diaphragm hooked up to a stylus that could etch lines into paper covered with lamp soot. It turned sound into squiggly lines on a piece of paper. Scott wasn't trying to make sound that could be played back. His goal was to make a paper record of speech that people might be able to read—a new kind of shorthand.

In 2008, a group of audio historians set out to see if it was possible to find and play some of the sounds Scott's machine transcribed to paper. They tracked down a few of his phonautograms, as the etchings are called, and made high-resolution scans of them. Then scientists at Lawrence Berkeley National Laboratory in Berkeley, California, created a virtual stylus that could play them.

Scott went to his grave convinced that Edison had stolen his ideas, but there is no evidence that Edison even knew about Scott's work. Edison's phonograph, invented in 1877, came out of his efforts to record telegraph messages for decoding later.

Several of the etchings yielded unintelligible squawks. But on one made April 9, 1860, a person can clearly be heard singing "Au Clair de la Lune." It is the oldest human voice we can listen to, recorded before Abraham Lincoln was president, still singing to us fifteen decades down the line.

Scott's patent application makes no mention of trying to play back the sounds, something that apparently did not occur to him. It does mention that his instrument might make good designs for jewelry, lamp shades, and book illustrations!

N° 7.

THE OTHER JOHN BROWN

Remembering the soldier behind the song behind the song

In 1859, abolitionist John Brown was hung after his failed raid on the Harpers Ferry Arsenal, which he hoped would trigger a slave uprising. He became a hero throughout the North, and in the early days of the Civil War, the song "John Brown's Body" swept across the country.

But the song actually started out being about *another* John Brown.

This fellow was a jovial Scotsman living in Boston. When war broke out, he joined a battalion of Massachusetts volunteers. They were sent to make repairs on crumbling Fort Warren in Boston Harbor. Sporting the same name as the abolitionist, Brown became a butt of constant teasing. Someone would call out: "That can't be John Brown . . . John Brown's dead." Another wag would shout: "His body lies a moldering in the grave." This seemed to the young men the height of hilarity.

Soon they were singing their humorous lyrics about his decomposing body to an old camp hymn called "Say, Brothers, Will You Meet Us" as a work song. "They were sung over and over again with a great deal of gusto," recalled one of Brown's comrades, "the 'glory hallelujah' chorus being always added."

When the Twelfth Massachusetts Regiment came to the fort, they, too, started singing the song. In July 1861, they sang it

John Brown the abolitionist. Before he was hung, he handed a slip of paper to the executioner that read, in part: "I, John Brown, am now quite certain that the crimes of this guilty land will never be purged away but with blood."

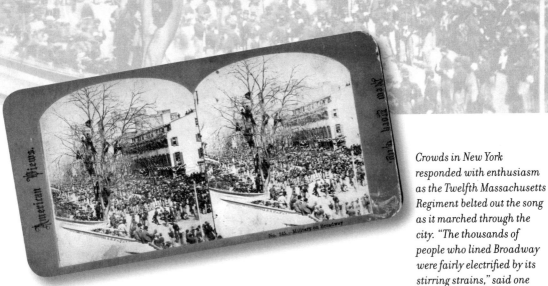

No. 355.—Military on Broadway

Crowds in New York responded with enthusiasm as the Twelfth Massachusetts Regiment belted out the song as it marched through the city. "The thousands of people who lined Broadway were fairly electrified by its stirring strains," said one member of the regiment, which was immediately dubbed the "Hallelujah Regiment."

while marching through New York City on their way to Washington. As a result, it caught the country's attention. It was on everyone's lips. Two months later, writer and abolitionist Julia Ward Howe wrote a new set of lyrics, titling her version "The Battle Hymn of the Republic."

John Brown the soldier was killed in battle on June 6, 1862. But his song goes marching on.

In September 1861, Julia Ward Howe and her husband, Samuel Gridley Howe, director of the Perkins School for the Blind, were inspecting the army camps outside Washington for the Sanitary Commission. They sang "John Brown's Body" along with the soldiers, and a friend encouraged her to write new lyrics. She recalled what happened the following morning. "To my astonishment [I] found that the wished-for lines were arranging themselves in my brain. I lay quite still until the last verse had completed itself in my thoughts." After she wrote it down, she said, "I lay down again and fell asleep, but not before feeling that something of importance had happened to me."

FROM DRUMMER BOY TO MAJOR GENERAL

The military exploits of the Civil War's youngest soldier

John Clem of Newark, Ohio, was just one of thousands of patriotic young men who sought to enlist in the Union army after the Confederates fired on Fort Sumter. But there was one thing different about him.

Clem was ten years old.

He ran away from home and stowed away on a train to a military camp. There he found a Michigan regiment willing to take him on as a mascot and drummer boy. He is believed to be the youngest soldier to serve in the Union army during the war.

Clem was given a drum and a sawed-off musket, and he learned to use both. After distinguishing himself at the Battle of Chickamauga, he became the youngest soldier ever to earn sergeant's stripes—he was twelve at the time. Clem's fame spread as newspapers across the country picked up the story of "The Drummer Boy of Chickamauga." He met President Lincoln at the White House and took Lincoln as a middle name.

At the Battle of Chickamauga, young Clem was cut off from the other soldiers in his regiment. A Confederate colonel came upon him and shouted, "Surrender, you damned little Yankee!" Instead, Clem shot him and got away. He later found out that the colonel he shot recovered from his wounds. "When I heard I had not killed that Confederate officer, it was the best news I ever got."

After the war was over, Clem wanted to go to West Point, but he failed the entrance exam. (Apparently drumming and shooting colonels didn't count for much.) When President Ulysses Grant heard the news, he cut through all the red tape and personally gave Clem a commission in the army.

After the war, at age twenty, Clem was commissioned a second lieutenant in the army. He rose through the ranks to become a colonel in 1903. More than fifty years after the war's end, John Lincoln Clem retired as a major general. He was the last Civil War soldier still on active duty.

The onetime drummer boy had come a long way.

TWENTY-FOUR NOTES

The Civil War general who whistled his way into history

Dan Butterfield was a New York businessman turned Union general. People seemed to love him or hate him. He was awarded a Medal of Honor for rallying his brigade under withering fire, but he had a bad temper that irritated fellow officers. One wrote that he was a man of "blemished character."

Perhaps so. But he also had poetry in his soul.

One night in July of 1862 he called the brigade bugler to his tent. Butterfield wasn't happy with the regulation bugle call played at the end of the day to signal "Lights Out." It wasn't very musical, he said.

The general had something different in mind. Since, by his own admission, he couldn't write a note of music, he whistled it for bugler Oliver Norton. When Norton played it back, it wasn't quite what Butterfield wanted, so they went back and forth for a while, the general whistling, the bugler blowing, until they had something Butterfield was satisfied with.

Norton used the new call that night. Buglers from other brigades camped nearby were so struck by it that they began using it as well. Soon the call spread to the whole army, and to the Confederate army as well.

And so a collaboration between a general and a bugler on a warm July evening led to twenty-four notes that have gone down in history: a haunting melody we all know, which announces the end of day for soldiers and graces the air at military funerals.

Taps.

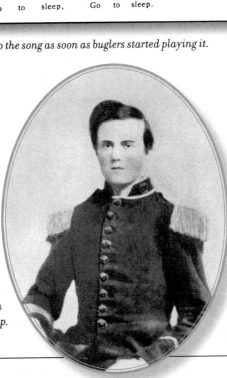

Put out the lights, Go to sleep, Go to sleep, Go to sleep, Go to sleep. Put out the lights, Go to sleep, Go to sleep.

Soldiers began making up words to the song as soon as buglers started playing it. These are some of the earliest.

Butterfield seems to have gotten the idea for the new bugle call from parts of an older call no longer in use, revising it to capture the mood he sought.

Trumpeter Oliver W. Norton recalled that Butterfield wanted a call that in its music should have some suggestion of putting out the lights and lying down to rest in the silence of the camp.

WATCHING THE CLOCK

*The granddaddy
of them all*

What would you call a six-foot-tall pendulum clock with a long wooden case? Most of us would refer to it as a grandfather clock. But when it was first invented in the late 1600s, people spoke of this kind of timepiece as a longcase or tallcase clock. Why do we call it a grandfather clock?

Because of a forgotten American songwriter named Henry Clay Work.

In the second half of the 1800s, Work was a popular songsmith whose tunes were on everybody's lips. In 1876, he wrote a song about an unusual clock.

> *My grandfather's clock was too tall for the shelf*
> *So it stood ninety years on the floor.*

The clock in the song keeps perfect time the man's whole life . . . right up until he breathes his last.

> *It was bought on the morn on the day that he was born*
> *It was always his treasure and pride*
> *But it stopped, short, never to go again*
> *When the old man died.*

"Grandfather's Clock" was a huge hit, selling a million copies of sheet music. It remains a hit today, having been recorded by everyone from Johnny Cash to Garrison Keillor to Boys II Men. And thanks to Work, those tall clocks got a name that banished all the earlier ones to obscurity.

Work's other big hit was the Civil War song "Marching Thro' Georgia," a jubilant march commemorating Union general William Tecumseh Sherman's triumphant "March to the Sea" across Confederate Georgia.

HENRY C. WORK:

AUTHOR OF

"Marching Thro' Georgia."

Hurrah! Hurrah! we sing the Jubilee,
Hurrah! Hurrah! the Flag that makes You Free;
So we sang the chorus from Atlanta to the Sea,
While we were Marching thro' Georgia.

According to one account, "Grandfather's Clock" was written after a visit Work made to the George Hotel in Yorkshire, England. The hotel had previously been operated by two brothers named Jenkins. It boasted a tallcase clock in the lobby that kept perfect time until one brother died; then it started losing time despite efforts to repair it. The clock stopped working at all on the day the second brother died. The hotel is still there today, along with the clock that reportedly started it all. And it is still not running!

THE PATRONESS

*The ultimate
long-distance
relationship*

W hen a rich Russian widow named Nadezhda von Meck first heard the music of composer Pyotr Tchaikovsky, it made her delirious. She fell head over heels for Tchaikovsky and his work. Soon she was sending him a monthly stipend so that he could quit his teaching job and write music full-time.

Over the next fourteen years, they exchanged hundreds of passionate letters, pouring out their feelings to each other. "You are life itself to me," she wrote. He became dependent on her financial and moral support, which enabled him to do his greatest work. What made their relationship unique, however, was a decision they made at the very beginning of it.

They vowed never to meet. "The more I am charmed," she wrote, "the more I fear meeting. I could not talk to you."

She invited him to spend weeks at her country estate—but only when she wasn't there. They exchanged travel itineraries so they wouldn't accidentally run into each other. She begged him for a photograph so she could study his face. But even when her son married his niece, they never met face-to-face.

After fourteen years she ended it, probably at the insistence of her family. "Do not forget," she wrote, "and think of me sometimes." When Tchaikovsky died four years later, the name of the widow he never met was on his lips.

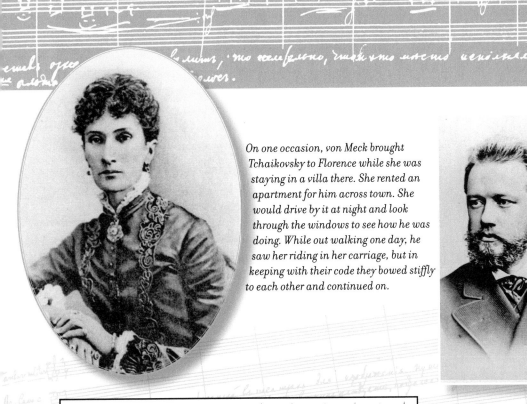

On one occasion, von Meck brought Tchaikovsky to Florence while she was staying in a villa there. She rented an apartment for him across town. She would drive by it at night and look through the windows to see how he was doing. While out walking one day, he saw her riding in her carriage, but in keeping with their code they bowed stiffly to each other and continued on.

Tchaikovsky's most famous work is his "1812 Overture." To the widow von Meck he confessed that it was "very loud and noisy, but [without] artistic merit, because I wrote it without warmth and without love."

THE SONG SHIP

Hawaiian music,

Portuguese style

In August 1879, a ship called the *Ravenscraig* pulled into Honolulu carrying laborers from the Portuguese island of Madeira bound for Hawaii's sugar fields. It also carried with it the seeds of a musical revolution.

A few days later, the *Hawaiian Gazette* reported that some of the recently arrived Portuguese were "delighting the people with nightly street concerts." The newspaper said the recent arrivals were playing a "strange instrument" that was a cross between a guitar and a banjo.

That little instrument struck a chord with the Hawaiians.

After working off their obligations to the sugar plantations that brought them to Hawaii, several of the men on the ship set themselves up in Honolulu as cabinetmakers. They also began turning out modified versions of their "strange instrument." Islanders snapped them up.

The diminutive four-stringed instrument the Portuguese had brought with them was known on Madeira as a "machete." In Hawaii, some people referred to the local version as a "taro patch fiddle." By the 1890s, it had been christened with a new name under which it would become famous the world over as a signature element of Hawaiian music.

The ukulele.

Three passengers on the Ravenscraig, Manuel Nunes, Augusto Dias, and José do Espírito Santo, eventually went into business making ukuleles. Nunes (right) later claimed to be the inventor of the instrument, but only after the other two had died.

The instrument became a favorite of Hawaiian king David Kalakaua. The name comes from the Hawaiian word uku meaning "flea" and lele "to jump." Some say it refers to the action of the fingers on the strings. Others claim that it was a derogatory nickname of a royal adviser named Edward Purvis who helped to popularize the instrument.

Hawaiian music featuring the ukulele became popular in the United States in 1915, after it was played at the Panama Pacific International Exposition in San Francisco. Nearly a hundred years later, its popularity is undiminished.

Seven-hundred-pound Hawaiian singer Israel Kamakawiwo'ole ("Bruddah Iz"), who died in 1997, earned fame the world over for his ukulele medley of "Over the Rainbow/What a Wonderful World."

George Harrison of the Beatles was a big fan of the ukulele. He collected them and often invited friends over to play them with him. During concerts, Paul McCartney sometimes plays Harrison's song "Something" on the ukulele in remembrance of his bandmate.

WANNA MAKE A RECORD?

Topping the charts . . . before there were any charts

America's first recording star was an African American street musician who started cutting records barely twenty-five years after the end of the Civil War. Long before there was Michael Jackson, Elvis Presley, or Frank Sinatra, George Washington Johnson was the undisputed number one back in the 1890s.

Born into slavery in Virginia, Johnson came to New York in 1873, where he eked out a living performing for coins aboard ferries. His specialty was whistling—which turned out to make him pretty valuable to the brand-new recording business. Thomas Edison's new "talking machine" was still quite primitive. The recordings it made on wax cylinders were not always clear.

But whistling came through just great.

A talent scout for the New Jersey Phonograph Company hired Johnson to start making records. The equipment could only record a half dozen copies at a time, so Johnson had to whistle or sing each tune as many as fifty times a day, getting paid twenty cents each time. Over the next ten years he made an estimated 50,000 recordings . . . far more than anyone else in the first decade of recording.

His songs sold all across the country. He performed in a stage play and whistled at a private concert for the Vanderbilts. But his success was fleeting. Accused of killing his wife in 1899, he was acquitted in a celebrity murder trial covered by all the tabloids.

LAUGHING SONG

OVER 50,000 RECORDS UP TO DATE FOR PHONOGRAPH USE ALL OVER THE WORLD.

GEO. W. JOHNSON, THE ORIGINAL

PUBLISHED BY KO-LA'R
302 W 36th St.
NEW YORK CITY.

WHISTLING COON AND LAUGHING DARKEY.

He fell from the public eye and died poor and forgotten years later—a cautionary tale for all who would follow in his footsteps.

Early phonographs were such a novelty that so-called phonograph concerts drew big crowds. Johnson's records were played in many of these, including a concert that drew two hundred people in Pittsburgh in May of 1891.

The titles and lyrics of some of Johnson's songs reflected the deep-seated racism of the day and are rightly offensive to modern ears. His two biggest hits were "Whistling Coon" and "Laughing Song," in which he laughed along in key with the chorus. Whistling and laughing were featured in almost all of his recordings.

The limitations of early recording equipment demanded performers who could cut through, and recording executives reflecting the biases of the day thought they had the answer. "Negroes . . . [are] . . . better than white singers," said an early recording industry newsletter, "because their voices have a certain sharpness or harshness about them that white voices do not."

THE FIRST MUSIC VIDEO

It's all been done

When MTV burst on the scene in 1981, music videos seemed like something brand-new. Actually, they had been around for nearly a century.

George Thomas was the chief electrician at the Amphion Theater in New York City when it hit him: Why not illustrate live performances of songs with a series of images projected by a magic lantern—an early prototype of the slide projector?

Thomas took dramatic photographs to illustrate a new song called "The Little Lost Child." He had them hand-painted in color and then unveiled his idea. The first performance was a disaster. The crowd booed when slides were inadvertently shown upside down. But once the glitches were straightened out, it became a huge sensation. The sheet music for the song sold more than 2 million copies.

Illustrated songs soon became a nationwide craze.

A fixture on the vaudeville circuit, they were seen in thousands of theaters. People made their reputations as "slide song singers." Many entertainers got their start posing for the pictures, including future stars Eddie Cantor and Fanny Brice.

The popularity of the phonograph and movies eventually put an end to the illustrated song business . . . until another generation could discover the power of music videos anew.

By superimposing one slide over another, the magic lantern could project shots of couples floating on a cloud or a face blooming from a flower—the birth of "special effects."

Norma Talmadge, who became one of the great stars of the silent film era, made her first on-screen appearance in an illustrated song when she was just fourteen years old. She posed for slides to accompany a song entitled "Stop, Stop, Stop (Come Over and Love Me Some More)," written by a still-unknown twenty-two-year-old named Irving Berlin.

A scene used to illustrate another popular song, "Just a Girl Like Mother Was."

GOOD MORNING TO ALL

This little tune

takes the cake

Patty Smith Hill was a pioneering educator who spent thirty years on the faculty at Columbia University. Her sister Mildred was a pianist and composer who also became a noted authority on African American music. Neither is remembered for their lives full of rich accomplishments, but instead for a brief musical collaboration back in the 1890s.

It just happens to be the most frequently sung song in the world.

Just twenty-five years old at the time, Patty Smith Hill was the principal of the Louisville Kindergarten Training School, where she put into place groundbreaking techniques on how to educate young children. She emphasized creativity, self-expression, and give-and-take between child and teacher, all ideas way ahead of her time.

As part of her efforts, Hill enlisted her musical older sister to collaborate with her on a collection of children's songs. The idea, she said, was to come up with "good music" that was both expressive and simple enough for young children to learn. That led to a book, *Song Stories for the Kindergarten*. One of the songs in the book was a tune called "Good Morning to All." Teachers could sing it to their children in the morning, or vice versa.

The Hill sisters had no way of knowing that their little song would become so popular that it would overshadow everything else they ever did. They could never predict that some unknown soul would write another set of lyrics to their tune, lyrics that are known today to just about everyone who speaks English, and millions upon millions who don't.

"Happy Birthday to You."

The "Happy Birthday" lyrics first showed up in the early 1920s, and the song achieved national popularity by the early 1930s. When Irving Berlin used it without permission in the 1933 musical As Thousands Cheer, it led to a lawsuit affirming the Hill sisters' copyright. The song is still under copyright protection, and under current law is expected to remain so until 2030. It earns Time Warner, which now owns the song, several million a year in royalties, mostly for use in movies and television shows.

Dr. Patty Smith Hill started teaching at age nineteen and kept working in the field of early childhood education until her death at age seventy-eight. She was awarded an honorary doctorate from Columbia University in 1929.

Did Mildred Hill also influence the composition of another famous piece of music? New York University music professor Michael Beckerman has offered persuasive evidence that she was the author of an influential 1892 article entitled "Negro Music" that helped inspire Antonin Dvořák's *New World Symphony*.

1894

Billboard

MUSIC POPULARITY CHART

Records Most Popular

National and Regional List of
BEST SELLING RETAIL RECORDS

CHARTBUSTER

The fascinating history of Billboard *magazine*

Billboard is famed the world over as the bible of the music industry. But it didn't start out that way. It was founded in 1894 as a magazine for bill posters.

In the late 1800s, posting bills was a popular form of advertising, and it was big business. Every night in cities across the United States hundreds of men, each armed with a stack of bills and a pail of paste, would spread out to put up the latest notices about theatrical shows, traveling circus acts, and carnivals. Companies vied for the right to post bills on abandoned buildings or lease out wall space. Competition was fierce.

One man in San Francisco went so far as to try to lease his wife's tombstone to a bill posting company.

Billboard advertised itself as the trade magazine "devoted to the interests of advertisers, poster printers, bill posters, [and] advertising agents." It wasn't too long before the magazine focused more on the attractions and less on the advertising. By 1900, it was billing itself as "The Official Organ of the Great Out-Door Amusement World." Soon it branched out to other forms of show business. The first ads for coin-operated jukeboxes came in 1901, and by 1940 music had become the dominant focus of the magazine.

That was the year of the first-ever *Billboard* popularity chart. "I'll Never Smile Again" by Tommy Dorsey became the very first *Billboard* number one hit . . . from coast to coast.

During most of the 1940s and 1950s, *Billboard* had different charts for sales in stores, radio plays, and jukebox plays. But in 1958, it combined all three into the *Billboard* Hot 100. Since then the charts—and the hits—have just kept on coming.

*B*illboard began charting songs by black musicians in 1942, in a chart called the "Harlem Hit Parade." Later the title was changed to "Race Records." Troubled by this offensive phrase, an editor named Jerry Wexler, who later went on to become a legendary record executive, coined a new phrase in 1949: "Rhythm and Blues."

TAKE A BOW (WOW)

*One dog's saga
to stardom*

Nipper was a mutt. Part fox terrier, part who-knows-what, the little dog lived in Bristol, England, with his master, a man named Mark Barraud. When Barraud died, the dog attached himself to Mark's younger brother Francis, following him everywhere.

Nipper was gullible. Paste a life-sized picture of a cat on a piece of cardboard, and he would attack it. Play something on the phonograph, and he would cock his head and puzzle over where the voice was coming from.

Nipper was cute. Francis Barraud painted a picture of him listening to that phonograph, which had a black horn. Nobody was willing to pay very much for it, and he decided that the painting would look better with a brass horn. He went to the offices of a new phonograph company to get one. The manager made him a deal: if Barraud would replace the old-style Edison cylinder phonograph with their brand-new disc phonograph, they would buy the painting for one hundred pounds.

That turned out to be the steal of the century.

Nipper was a star. The painting and the title Barraud gave it—*His Master's Voice*—would become one of the most famous trademarks in the music business, first for the Victor Talking Machine Company, then for RCA. More than a century after his death, Nipper is recognizable around the globe, has adorned millions of records and CDs,

has been parodied endlessly, and continues to appear in RCA advertising today.

Good dog!

His Master's Voice has been used as a trademark the world over, and the title translated into dozens of languages. In France it is La Voix de son Maître; in Germany, Die Stimme seines Herrn; in Sweden, Husbondens Röst; and in Turkey, Sahibinin Sesi.

A giant four-ton Nipper sits atop the former headquarters of an RCA distributor in Albany, New York. It is believed to be the largest man-made dog in the world. A matching phonograph used to sit on top of the facing building, which has since been torn down.

" IT CERTAINLY WAS THE HAPPIEST THOUGHT I EVER HAD. "

—FRANCIS BARRAUD, ON HIS DECISION TO PAINT NIPPER

Nipper became so famous that in the 1950s, an attempt was made to excavate his remains, but they could not be found.

RIDICULOUS TO SUBLIME

*Foggy sound
leads to a
symphonic
sensation*

Boston's Symphony Hall, which opened in 1900, is considered one of the best concert halls in the world. And it all began with another room that was the exact opposite.

Five years earlier, Harvard University built the Fogg Museum. Its main lecture hall was supposed to be a gem. Instead, it was a disaster. The acoustics were abominable. Speakers were impossible to understand. Something had to be done!

The Harvard Corporation ordered the school's Physics Department to find a solution. This was one job nobody wanted—it seemed doomed to failure. Eventually it ended up in the lap of the department's lowest-ranking faculty member, Wallace Clement Sabine. Sabine had no special training in sound, but he set out to see what he could do.

Up until that time, room acoustics was largely a matter of guesswork. Armed with just a few crude instruments, Sabine made thousands of measurements to quantify the room's reverberation. He had to do all his work between 2:00 a.m. and 6:00 a.m., when the sound from the streetcars didn't interfere. He sent students out each night to filch seat cushions from nearby Sanders Theatre to see how they changed the sound. (As a result, the first unit of sound absorption was a one-meter length of a Sanders seat cushion material.)

Sabine didn't just fix the Fogg, he single-handedly created the field of architectural acoustics. The president of Harvard recommended that he be brought in to consult on the building of Symphony Hall, and famed

architect Charles McKim accepted the young professor as a virtual coarchitect. The result: a hall that cellist Yo-Yo Ma has called: "A rare and incalculably refined instrument unto itself." Words that would be music to the ears of the scientist who made it happen.

Famed architect Richard Morris Hunt, who designed the Fogg Museum, was once asked how much he knew about acoustics. "As much as anyone," replied Hunt. And how much was that? "Not a damned thing," admitted Hunt.

One other change Sabine made was to alter the design of the organ. This angered the organ maker, who ranted, "I was making organs before he was born." But he later admitted that Sabine's change improved the sound of his instrument.

Sabine suggested that Symphony Hall should have a rectangular shape, and that the ceiling over the stage should be lower than the rest of the hall. He invented a quiet heating and ventilation system and carefully shaped the walls and floor of the stage so that they project music out toward the audience.

THE MENACE OF MECHANICAL MUSIC

*Sousa's song
of sorrow*

Sweeping across the country with the speed of a transient fashion in slang or Panama hats, political war cries or popular novels, comes now the mechanical device to sing for us a song or play for us a piano, in substitute for human skill, intelligence, and soul.

So begins a stem-winder of an angry rant by a man more famous for his marches than his missives. Bandleader and composer John Philip Sousa feared that recorded music was crushing the musical soul of the United States, and he went public with his concerns in a 1906 magazine article entitled "The Menace of Mechanical Music":

> I foresee a marked deterioration in American music and musical taste, an interruption in the musical development of the country, and a host of other injuries to music.

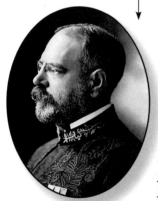

With recorded music so easily available, Sousa protested, people would stop learning to play music, perhaps even to sing, and simply listen to "canned" music:

> Then what of the national throat? Will it not weaken? What of the national chest? Will it not shrink? When a mother can turn on the phonograph with the same ease that she applies to the electric light, will

Sousa's concerns were genuine, but he also admitted to being motivated by another factor. At the time of his rant, composers were not paid royalties for recordings. The fledgling recording industry, he felt, was picking his pocket.

Sousa led the US Marine Band from 1880 to 1892 and conducted his own band from 1892 to 1931, playing in more than fifteen thousand concerts. Ironically, his bands were among the most popular recording groups of the early twentieth century. But out of the thousands of recordings made by his band, he was personally involved in only eight.

she croon her baby to slumber with sweet lullabies, or will the infant be put to sleep by machinery?

Sousa's apocalyptic tone strikes the modern ear as a bit humorous, but by and large, the future he feared has unfolded. Recorded has supplanted live music in much of our daily lives. Whether we have been enriched by its variety or, as Sousa predicted, impoverished by its soullessness, is a question for the ages.

> **THESE TALKING AND PLAYING MACHINES . . . REDUCE THE EXPRESSION OF MUSIC TO A MATHEMATICAL SYSTEM OF MEGAPHONES, WHEELS, COGS, DISKS, CYLINDERS, AND ALL MANNER OF REVOLVING THINGS.**
>
> —JOHN PHILIP SOUSA

FIRST MAN OF JAZZ?

The mystery of
Buddy Bolden

When Louis Armstrong was five years old, he heard a horn player through the window of the Funky Butt Hall on Perdido Street in New Orleans. "He blew so hard," said Armstrong in his autobiography, "that I used to wonder if I would ever have enough lung power to fill one of those cornets."

That horn player was Buddy Bolden, who may have been the very first jazz musician.

Bolden became a popular New Orleans bandleader around 1900, when he was in his early twenties. There's something tantalizing about his story. We know so little about him, or his music. If he ever made a record, it didn't survive. He couldn't read music, so nothing was ever written down. There's no way to know what it really sounded like. People who heard him said he played loud, he played hot, he played with personality. The Buddy Bolden band was *different,* somehow, managing to play more vibrantly than anyone else. "There are those still living who can testify to his imaginative improvisations," wrote a New Orleans journalist in 1940.

By 1906, he was the most popular black musician in New Orleans. He was known as "King Bolden." But a year later it was all over. Always a heavy drinker, Bolden began suffering severe headaches and became paranoid. In 1907, his mother became so fearful that she committed her thirty-year-old son to the state insane asylum, where he spent the last twenty-five years of his life.

Bolden was a huge influence on the next generation of New Orleans musicians, the players who shaped and molded jazz. If he had lived longer, if he had made recordings that survived, it might be easier to understand just what it was that was so special about his playing, and whether he really deserves to be called the very first jazz musician. But that's a mystery that Buddy Bolden took to the grave with him.

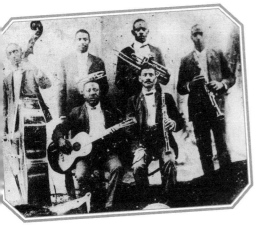

The only known picture of Buddy Bolden, with his six-piece band. Bolden is second from left in the rear. Bolden couldn't read music, so for him improvisation was everything. His style apparently involved "ragging" on the melodies . . . playing two or three notes for every one in the original tune.

Jazz great Jelly Roll Morton paid tribute to Bolden with his song "Buddy Bolden's Blues."

" WHEN YOU COME RIGHT DOWN TO IT THE MAN WHO STARTED THE BIG NOISE IN JAZZ WAS BUDDY BOLDEN. HE WAS A POWERFUL TRUMPET PLAYER, AND A GOOD ONE TOO. I GUESS HE DESERVES CREDIT FOR STARTING IT ALL. "

—TRUMPETER MUTT CAREY, WHO STARTED PLAYING JAZZ IN 1912

KATIE'S LAMENT

A musical grand slam

As Jack Norworth told the story, it happened on the subway. Norworth was a twenty-nine-year-old vaudeville actor, a veteran of Ziegfeld's Follies who got his start doing blackface comedy. Riding a New York City subway one day in 1908, he saw a sign advertising baseball at the Polo Grounds, home to the New York Giants.

Not a baseball fan—he had never attended a major-league game—Norworth was nonetheless inspired to write a song about a baseball-mad young lady named Katie Casey. He dashed off the lyrics on the back of an envelope in about fifteen minutes. The song describes how Katie "had the fever, and had it bad," how she saw all the home games, knew all the players by name, and wasn't afraid to call the umpires wrong. Forgettable stuff, for the most part.

The verses, that is. The chorus is a different story.

In the song, Katie's beau offers to take her to see a show, but Katie has something else in mind. "I'll tell you what you can do," she says. Today, more than a hundred years after the song was written, nobody remembers Katie Casey, but almost everybody in America can sing the words of Katie's plea:

"Take me out to the ball game . . ."

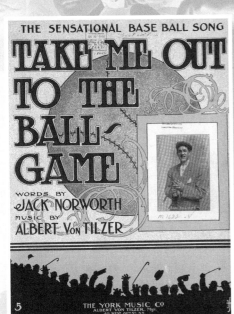

The words were set to music by composer Albert von Tilzer, who had also never seen a baseball game.

A crowd watches the Cubs play the Giants at the Polo Grounds in New York the same year the song was written.

Norworth once said that he wrote "more than three thousand songs, seven of them good." His other big hit was "Shine On, Harvest Moon."

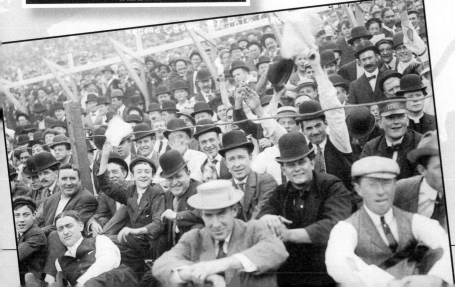

ANYBODY OUT THERE?

Radio takes center stage

On January 13, 1910, the legendary tenor Enrico Caruso stepped onto the stage of New York's Metropolitan Opera and began to sing an aria from *I Pagliacci*. But this performance was unlike any that had ever come before.

It was the very first live concert beamed to a radio audience.

Up until then, the new technology had been used mostly for point-to-point communication, especially ship to shore. But radio pioneer Lee de Forest had a different vision: using radio to bring entertainment and information to the public. To demonstrate the power of his idea, he suspended microphones over the stage, installed a 500-watt transmitter, and erected antennas on the roof of the Opera House.

"The warbling of Caruso," said the *New York Times* grandly the next day, was "borne by Hertzian waves over the turbulent waters of the sea to transcontinental and coastwise ships and over the mountainous peaks and undulating valleys of the country."

The reality was a bit more prosaic. The weak signal barely reached to Newark, New Jersey. Perhaps fifty people tuned in: a handful of radio enthusiasts, a dozen shipboard radio operators, and a few reporters. And not all of them could hear it clearly. Some reported interference from a radio-telegraph operator transmitting that he had just come back from having a beer!

But if listenership wasn't huge, the idea was. This was the birth of *broadcasting*, aiming radio at a broad audience instead of a single person far away. Every performer who has graced the airwaves since is simply following in the footsteps of Caruso.

Caruso was the first great recording star of the twentieth century, making more than 250 recordings during his lifetime.

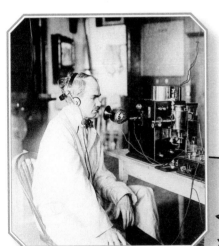

De Forest had 180 patents to his name, including one for the Audion tube, a critical component in early amplifiers.

The old Metropolitan Opera House, site of the broadcast.

WIRED WIRELESS

*The aviation pioneer
who gave music a lift*

George Owen Squier was a major in the Army Signal Corps when he supervised testing of the Wright brothers' plane in 1908. His flight with Orville Wright made him one of the first passengers ever to ride in an airplane, and he was instrumental in convincing the army to buy the Wright plane. Later, during World War I, he commanded the Army Air Corps.

Squier was also a prolific inventor with more than sixty patents to his name. In 1911, he patented a technology that allowed many radio signals to travel over a single wire. He called it "Wired Wireless."

After Squier retired from the army, he launched a company to bring "Wired Wireless" to America. For two dollars a month, consumers could have radio programs piped into their home over the electrical wires. It was an idea way ahead of its time—an early forerunner of cable TV. But people proved unwilling to pay for radio when they could get it for free. So Squier's company began targeting businesses, commissioning studies to show how piped-in music increased employee efficiency.

Squier's company was called Wired Radio, but in 1934, he came up with a catchier moniker, merging the word "music" with the name of his favorite "high-tech" company, Kodak.

The result: Muzak, now heard in retail stores, restaurants, malls, offices—and of course elevators—by more than 100 million people a day.

Squier's radio research led him in some strange directions. One subject of particular interest was "tree telephony." He tried hammering copper nails into a tree to turn it into a radio antenna capable of receiving shortwave signals. He called this a "flora phone."

Squier was lucky in the timing of his flight. Thomas Selfridge, another army officer flying with Orville Wright, was killed in a crash a few days later—becoming the first passenger ever to die in an airplane accident.

RIOT OF SPRING

A classical premiere that rocked the music world

The curtain went up at 8:45 p.m. The conductor waved his baton and the orchestra began to play. The angry shouts and jeers began moments later. Fistfights broke out among audience members. Some stalked out of the hall in outrage. One bejeweled socialite spit in the face of the man sitting next to her. Two concertgoers got so worked up they reportedly fought a duel the next day.

Not just another night at the ballet.

The occasion was the world premiere production of *Rite of Spring*, at the Théâtre des Champs-Elysées in Paris. The avant-garde ballet, composed by Igor Stravinsky and choreographed by the famed dancer Vaslav Nijinsky, ignited an audience response rare in the dignified world of classical music:

Angry mayhem.

The subject matter was controversial: a pagan ritual in which a virgin dances herself to death. Stravinsky's dissonant music was jarring to many ears. "To say that much of it is hideous as sound is a mild description," wrote the *Musical Times* of London. Nijinsky's radical choreography looked to some like aimless movement. The audience that opening night took sides immediately, and a war of sorts broke out in the aisles. One observer said the music was drowned out by "the disjointed ravings of a mob of

A piece of Stravinsky's Rite of Spring *music was later used in the 1940 Disney film* Fantasia. *Stravinsky was infuriated by the way his music was edited.*

angry men and women." Another said the theater seemed "shaken by an earthquake."

Times change. Today Stravinsky's *Rite of Spring* is hailed as one of the great masterpieces of twentieth-century music, a break with the past that signaled a new era. And it hardly ever provokes audience members to riot anymore.

Nijinsky had already become famous for his provocative dancing in earlier productions. During the raucous opening of Rite of Spring, he had to stand on a chair in the wings calling out numbers to the dancers because they could barely hear the music over the angry crowd.

> **WHO WROTE THIS FIENDISH *RITE OF SPRING*,**
> **WHAT RIGHT HAD HE TO WRITE THE THING,**
> **AGAINST OUR HELPLESS EARS TO FLING**
> **ITS CRASH, CLASH, CLING, CLANG, BING, BANG, BING?**
>
> —AN ANONYMOUS POET WRITING IN THE *BOSTON HERALD* IN 1924, AFTER THE AMERICAN PREMIERE

DANCE FEVER

It takes two to tango

It took the country by storm, dividing America into two opposing camps: those caught up in its passion, and those determined to stamp it out. What was it?

The tango.

Born in the slums of Buenos Aires, the dramatic dance swept across Europe and America in 1913. "Go where you will, it is impossible to escape it," opined a Nebraska newspaper. Tango teas and tango classes became all the rage. The French Quarter in New Orleans became known as the "Tango Belt" because of all the new dance halls. In Atlantic City the trolley company introduced a "Tango Car" for those determined to dance their way to and from work.

Not everyone was thrilled. Cleveland and Baltimore banned the dance. Boston stationed policemen at dance halls to take down tangoers. Harvard University prohibited any member of the track team from doing the tango, declaring that the dance "does not tend to make outdoor athletes."

Conflict was inevitable. Pittsburgh teachers went on strike when forbidden to tango. Dancers at a church social in Connecticut rioted when told the tango was a

Come let's make a date
To Tango quite late,
And when we get tired
We'll just Hesitate.

The tango is believed to have originated as a North African dance that spread to Spain and eventually Argentina, where it became popular in the late 1800s and developed into the dance we know today.

BEACH TANGO - BRIGHTON 313 4 - 10

no-no. A soloist at an Atlantic City church choir was told to choose between the tango and the choir. She left the choir.

America's tango fever eventually subsided, but it proved to be a preview of things to come: culture wars over jazz, rock 'n' roll, hip-hop, and other music and dance crazes feared as threats to our way of life. Still, we keep going.

Evangelist Bob Jones said New Yorkers were tangoing themselves to "the brink of hell," and added, "The only difference between Manhattan and hell is that Manhattan is surrounded by water."

The tango also ran into opposition in Europe. Kaiser Wilhelm banned German military officers from attending any function where the tango was danced. The pope called the dance "offensive to the purity of every right-minded person." In 1915, even while France was in the midst of World War I, Paris authorities expelled five tango teachers from the city.

YOU SAY YOU WANT A REVOLUTION

The complex history of a Mexican folk favorite

L a Cucaracha" is a song full of surprises. The energetic tune popular among mariachi bands features lyrics about a cockroach that smokes marijuana and owes its popularity to the Mexican Revolution. What's more, it is directly connected with the women who played an unsung role in that war.

The song originated in Spain and came over to Mexico in the 1800s. But the song really caught fire in the Mexican Revolution that took place between 1910 and 1920. Many new lyrics were written at that time, and soldiers on all sides sang it fervently. The one lyric in almost all the versions is the chorus:

> *The cockroach, the cockroach*
> *Does not want to travel*
> *Because it's missing, because it's lacking*
> *Marijuana to smoke.*

The cockroach became a symbol for various things, depending on just who was singing which set of lyrics. Some said it stood for Mexican president Victoriano Huerta, ridiculed by his enemies as a dope fiend. Others insisted it referred to Pancho Villa's rebel army, swarming all over Mexico like cockroaches. Villa's men, in turn, empathized with the cockroach forced to

One legend claims that Pancho Villa's car was nicknamed "The Cockroach." Villa himself loved to sing while his army was on the march, and the song was one of his favorites.

travel long distances without its favorite form of relaxation.

Female *soldaderas* who followed and sometimes fought with the warring armies were dismissively referred to as *cucarachas,* which is also slang for "dried-up old maid." Yet they, too, embraced their own versions of the song.

Next time you hear "La Cucaracha," you'll know the story of the cockroach loved by all during Mexico's time of tumult, and still remembered today.

Soldaderas were women who left hearth and home and took up arms during the revolution. The term also came to encompass camp followers who traveled with the armies, cooking meals and providing comfort to the soldiers. The soldaderas are widely celebrated in Mexican songs and art. This particular set of lyrics from 1915 explains the hardships of camp life: no starch, no ironed clothes, no money, no soap. And instead of lacking marijuana, la cucaracha no longer has money to go out to the bullring.

CORRIDO DE LA CUCARACHA

QUE NO HA SALIDO A PASEAR, PORQUE NO TIENE QUE GASTAR.

MUSICAL MERRY-GO-ROUND

The exhausting history of the Russian national anthem

It is a striking fact that in the last hundred years, the Russians have had more national anthems than even the most patriotic citizen could reasonably be expected to keep track of.

Up until 1917, the anthem was "God Save the Tsar." Tsar Nicholas's overthrow that year necessitated a new choice. The provisional government went with a Russian variation of the French patriotic song "La Marseillaise." When the Bolsheviks took power the following year and created the Soviet Union, it was out with the old anthem and in with "The Internationale," another French song identified with world communism.

During World War II, the Soviet Union was locked in mortal combat with Nazi Germany. Soviet leader Joseph Stalin decided this was the perfect time to hold a national contest for a new locally produced anthem, which was adopted in 1944. The lyrics were full of praise for Stalin. That proved a problem after his death, when the horrors of his regime began to

Poet Sergei Vladimirovich Mikhalkov may be the only man in history who got to write lyrics to his country's national anthem three times . . . over the course of sixty years. In 1944, Stalin picked him to cowrite lyrics to the new anthem by Alexander Alexandrov. In the 1970s he was called on to write new lyrics that dropped any mention of Stalin. And in 2000, at the age of eighty-seven, he picked up his pen once again to write yet another set of lyrics dropping all references to Lenin and the Soviet Union and singing the praises of Mother Russia. Russian president Vladimir Putin presented him with a special award in 2008.

leak out. The Soviet government solved the problem by banning the lyrics for its own anthem. It became known as "The song with no words." It wasn't until twenty years later that new lyrics were adopted.

The fall of the Soviet Union required yet another new anthem for Russia. This instrumental piece, called the "Patrioticheskaya Pesnya," lasted less than a decade. Once again the Russians had an anthem with no lyrics, and a tune that most people didn't even know.

In 2000, Russian president Vladimir Putin decided that the country should go back to the old Soviet anthem, but with new lyrics. The choice was considered controversial at the time, but thanks to Putin, the Russians finally have an anthem that doesn't need changing.

For now.

> " RUSSIA—OUR HOLY NATION,
> RUSSIA—OUR BELOVED COUNTRY.
> A MIGHTY WILL, GREAT GLORY—
> THESE ARE YOURS FOR ALL TIME! "
>
> —LYRICS TO THE LATEST VERSION OF THE RUSSIAN NATIONAL ANTHEM

President Putin was moved to readopt the old anthem after watching Russian gold-medal winners at the Sydney Olympics unable to sing along with their wordless and largely unfamiliar national anthem.

Joseph Stalin.

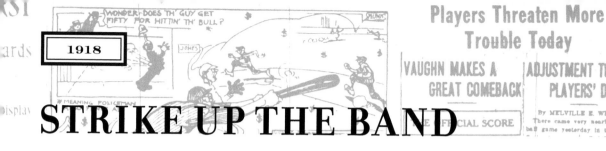

STRIKE UP THE BAND

Please rise, and hear how the national anthem came to be played before ball games

On September 11, 1918, Game Five of the World Series was scheduled for Fenway Park in Boston. The Red Sox were going to play the Chicago Cubs, and since this was during World War I, many wounded veterans would be in the stands.

The start of the game was delayed when a dispute arose over—guess what—money. (There is, after all, nothing new in sports.) Players were upset that they weren't getting a bigger share of the World Series purse, so they decided to strike. They refused to take the field. Hasty negotiations took place under the stands, as fans grew impatient.

After about an hour, the players reluctantly agreed to play ball for the sake of the vets. Caught up by the patriotic fervor (and no doubt trying to placate the restless crowd), the happy Red Sox owner had the band strike up "The Star-Spangled Banner." It was the first time the song is known to have been played before a ball game.

The wartime fans rose and doffed their hats out of respect, and a new tradition was born. The Red Sox went on to win the Series, the last one they would capture for eighty-six years.

The New York Times thought playing the anthem before the game so out of the ordinary that it devoted a headline to it. (It wasn't officially the national anthem yet, but it was already considered so by many people.)

NATIONAL ANTHEM OPENS THE AFFRAY

Lively Battle Waged in Which Hippo Vaughn Is Controlling Factor Throughout.

BOSTON, Sept. 10.—The band played "The Star Spangled Banner" while the players and spectators stood with bared heads. Vaughn pitched for the Cubs, while Sam Jones, Boston's right-hander, was the selection for Boston.

Red Sox outfielder Harry Hooper drew much criticism for his role in organizing the strike. A New York Times reporter sarcastically referred to him in print as "Comrade Hooper." A slightly hysterical Boston Post columnist wrote: "Professional baseball is dead . . . killed by the greed of players and owners." That judgment seems in retrospect to be a bit premature.

> ❝ WE'LL PLAY . . . FOR THE SAKE OF THE WOUNDED SAILORS AND SOLDIERS WHO ARE IN THE GRANDSTANDS. ❞
>
> —HARRY HOOPER, RED SOX OUTFIELDER

HOOPER-BOSTON-AMER.

SOLD FOR A SONG

The Boston Tea Parting

"Tea for Two" is a bouncy, happy song written in the 1920s. Over the years, the familiar tune has become a jazz standard. Doris Day sang it in the movies. Tommy Dorsey and Ella Fitzgerald came up with their own versions.

It is also a song that any die-hard Boston Red Sox fan should loathe to the very depths of his or her soul. Why? Because it was made possible by the darkest day in Red Sox history: the day that Babe Ruth was sold to the Yankees.

Red Sox owner Harry Frazee was first and foremost a theatrical producer. Deep in debt in 1919, he sold his star player to the Yankees for one hundred thousand dollars. As part of the deal, he also received a three-hunded-thousand-dollar loan from the owners of the Yankees.

Sox fans howled, but Frazee had his sights set on Broadway.

He used a chunk of the money to finance a play called *My Lady Friends* that opened just about the same time Ruth was traded. When it turned out to be a modest success, he used more of his windfall to turn the play into a musical, which opened in 1925.

Although he owned the Red Sox, Frazee was far more comfortable in the Big Apple. "The best thing about Boston," he once said, "is the train ride back to New York." After the trade, Frazee was viewed as a blackguard and villain by generations of Red Sox fans.

No, No, Nanette was a smash hit. Its biggest song was "Tea for Two," a duet about a couple imagining their future together. "Can't you see how happy we will be" runs one line of the lyrics. But the future it promised for the Red Sox was anything but happy: eight decades without winning a World Series.

A bitter cup of tea for Boston.

Babe Ruth, the way Red Sox fans would like to remember him—in a Boston uniform.

66 **PICTURE ME UPON YOUR KNEE, WITH TEA FOR TWO AND TWO FOR TEA, JUST ME FOR YOU AND YOU FOR ME, ALONE!** 99

—"TEA FOR TWO"

I READ THE NEWS TODAY, OH BOY!

Nothing like a little pressure to inspire a masterpiece

I ra Gershwin opened the *New York Herald* one January day and read that his brother George was working on a "jazz concerto" that would premiere in just a few weeks.

That was news to George Gershwin.

Bandleader Paul Whiteman was putting on a concert billed as "An Experiment in Modern Music," grandly announced as an effort to bring jazz to the concert hall. He had talked to Gershwin about contributing something, but Gershwin didn't think anything definite had been agreed upon. The whole thing had slipped from his mind.

Now he was on the spot.

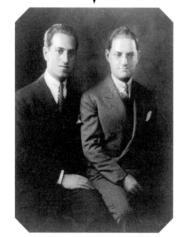

The twenty-five-year old composer was busy working on a new musical called *Sweet Little Devil*, and other projects were piling up. There wasn't enough time! Whiteman pleaded with him to write a simple score—an arranger could orchestrate the rest. So Gershwin frantically wrote out a piece, sending each page to arranger Ferdinand Grofe as it was done. He was

George (left) *called his piece "American Rhapsody." His brother Ira* (right), *the wordsmith in the family, came up with a far better title, finding inspiration in one of his favorite paintings: James Whistler's* Nocturne in Blue and Silver.

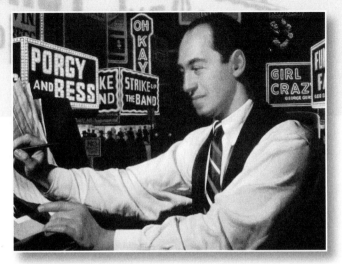

so pressed for time he never got to the solo piano parts—he would just improvise them at the concert.

It didn't have a whole lot to do with jazz, but what Gershwin and Grofe created under the press of deadline proved to be one of the most enduring and popular pieces of American music of all time, "a musical kaleidoscope of America" Gershwin called it.

"Rhapsody in Blue."

Clarinet player Ross Gorman was described by one music critic as a "virtuoso and imp of the perverse." Goofing around during rehearsal, he played the opening notes of the piece with what he considered a humorous send-up, sliding from one note to the next. Gershwin told him to play it like that in the concert, getting as much "wail" as possible. The result is one of the most arresting song opens in music.

Paul Whiteman was one of the most popular American bandleaders of the 1920s and 1930s. He became known as the "King of Jazz," and his band introduced many Americans to a somewhat smoothed-over version of this emerging music. Whereas most jazz musicians embraced improvisation, Whiteman thought the genre could be refined by orchestrating it with formal written arrangements.

I BEG YOUR PARDON

The prisoner who sang himself out of jail

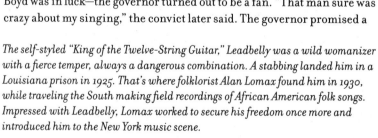

Walter Boyd was six years into a thirty-year sentence for murder on the day that Texas governor Pat Morris Neff came to visit the prison farm. In addition to being known as one of the hardest workers in the labor gang, Boyd was a wizard on the guitar, and after supper he was invited to come play for the governor.

He made the most of his opportunity, belting out a song he had written specially for the occasion:

> *If I had the governor*
> *Where the governor has me,*
> *Before daylight*
> *I'd set the governor free.*

> *I begs you, governor*
> *Upon my soul:*
> *If you won't give me a pardon*
> *Won't you give me parole.*

Boyd was in luck—the governor turned out to be a fan. "That man sure was crazy about my singing," the convict later said. The governor promised a

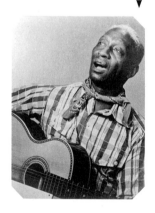

The self-styled "King of the Twelve-String Guitar," Leadbelly was a wild womanizer with a fierce temper, always a dangerous combination. A stabbing landed him in a Louisiana prison in 1925. That's where folklorist Alan Lomax found him in 1930, while traveling the South making field recordings of African American folk songs. Impressed with Leadbelly, Lomax worked to secure his freedom once more and introduced him to the New York music scene.

pardon, and on his last day in office he delivered.

The name "Walter Boyd" was just an alias. The prisoner's real name was Huddie Ledbetter, and he would eventually earn international fame as a folk and blues musician under his nickname "Leadbelly." His career included performing with Woody Guthrie, hosting his own radio show, and writing the million-seller "Goodnight, Irene."

But of the hundreds of songs he sang, none paid off as much as the one that earned him his freedom.

Governor Neff was so tickled by the incident that he would frequently retell the story to friends, singing the plea for freedom as Leadbelly had sung it to him. Neff later became president of Baylor University.

> **THIS NEGRO WOULD PICK HIS BANJO, PAT HIS FOOT, ROLL HIS EYES, AND SHOW HIS BIG WHITE TEETH AS HE CAROLED FORTH IN NEGRO MELODY HIS MUSICAL APPLICATION FOR PARDON.**
>
> —TEXAS GOVERNOR PAT MORRIS NEFF

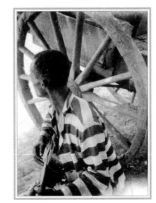

THE DRUMS OF WAR

*From the battlefield
to the Jazz Age*

A lot was expected of Civil War drummers. They kept time on marches, rapped out orders on the battlefield, and played music with the regimental band. They were expected to play loudly and consistently and keep it up all day long if needed.

In the early 1920s, a drummer named Sanford Moeller became fascinated with understanding just how they managed it. He began to haunt nursing homes, querying shriveled old men who had served as drummer boys during the bloody conflict decades before. Moeller discovered that those wartime drummers had a unique way of playing, with a high arm movement for volume, and an almost unheard-of way of holding the drumsticks in order to ease fatigue.

Moeller was a drumming fanatic who passed along what he called the "ancient grip" in his 1925 book *The Art of Snare Drumming* and in lessons to students. One of the students who studied under him was an up-and-coming young jazz drummer from Chicago. The techniques he learned from Moeller helped him to create a style all his own.

His name was Gene Krupa.

The style Moeller learned from the Civil War drummer boys involves holding the drumstick like a hammer, with only the little finger curled around the stick. The hand is brought down in a lightning-fast whipping action. Legendary drum instructor Jim Chapin (whose sons Harry and Tom Chapin achieved considerable music fame of their own) spent much of his career passing on the Moeller technique to succeeding generations of drummers. He said that mastering it can make a drummer's playing "like a dance in midair."

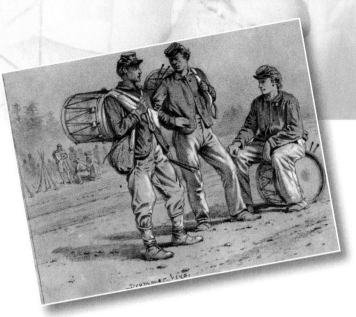

Krupa would go on to become a jazz legend. Playing for the Benny Goodman band, he practically invented the modern drum solo in the 1937 hit "Sing, Sing, Sing." Krupa's style and flair turned the drummer from a timekeeper to a showstopper—with a little assist from the drummer boys of long ago.

Moeller has achieved almost cultlike status among drum aficionados. He served in the army in the Spanish-American War, and supposedly played for George M. Cohan during his vaudeville career. Moeller crafted vintage-style drums, including the one he is pictured with here. In 1930, as a PR stunt, he walked from his New York shop to Massachusetts dressed in a colonial costume and drumming all the way.

I MADE THE DRUMMER A HIGH-PRICED GUY.

—GENE KRUPA

LOOK, MA, NO HANDS

Good vibrations from a Russian genius

In 1927, a mediocre musician from Moscow became an overnight sensation. Crowds overran the Paris Opera to hear him perform. He was offered $35,000 to appear at Carnegie Hall— a record at that time. Internationally renowned musicians packed the front rows of his first U.S. concert, eager to drink in his performance.

It wasn't the limited musical talent of Leon Theremin that captivated audiences. It was the strange and wonderful instrument the Russian scientist had invented. It looked like a futuristic radio with two antennas, and it worked as if by magic. Theremin simply waved his hands around the antennas to coax mysterious and eerie tones from it. Hundreds of thousands of people flocked to his "ether wave" concerts, as they were called.

The "theremin" was the first truly popular electronic instrument, in many ways the predecessor of all synthesized music that's come since. Its out-of-this-world sound became a staple of many science-fiction movies, including *The Day the Earth Stood Still,* and a modified version of the instrument was used on the Beach Boys' hit song "Good Vibrations."

But that was only part of Theremin's amazing career.

Henry Cabot Lodge revealing the bug in "The Great Seal." Theremin's listening device became known in intelligence circles as "The Thing." The Soviet Union secretly awarded Theremin the Stalin Prize for his work on high-tech eavesdropping equipment.

In 1960, the United States dramatically revealed to the world a KGB listening device found in the office of the U.S. ambassador to the Soviet Union. It was planted in a wooden carving of the "Great Seal of America." The ingenious device had no wires or circuits, required no battery, and had taken years to detect. Its inventor?

Leon Theremin.

> ❝ **A CELLO LOST IN A DENSE FOG AND CRYING BECAUSE IT DOES NOT KNOW HOW TO GET HOME.** ❞
>
> —*NEW YORK TIMES* MUSIC CRITIC HAROLD SCHONBERG DESCRIBING THE SOUND OF A THEREMIN

In 1922, Theremin presented his instrument to Soviet leader Vladimir Lenin. Lenin liked it so much that he insisted Theremin teach him how to play it and then encouraged the inventor to go out and present it to the world.

The theremin can be heard on numerous other songs, including Led Zeppelin's "Whole Lotta Love." But that's not a theremin playing on the original *Star Trek* theme. It's soprano Loulie Jean Norman.

BRISTOL BANG

The birthplace of country music

On Monday, July 25, 1927, a New York record producer named Ralph Peer set up his mobile recording equipment in an empty storage space above a hat factory on State Street in Bristol, Tennessee.

What happened next has been called the Big Bang of country music.

The success of several earlier records had convinced music executives that there was a market for what they called "hillbilly music." Peer had journeyed to Bristol, nestled in the mountains along the Virginia/Tennessee border, to see if he could find some authentic local talent.

Boy, did he.

Ads and articles in the local paper attracted nineteen different groups to Bristol. Over the next ten days they recorded seventy-six songs, nearly half of which were eventually released as records. Among the artists who answered the call, Peer discovered two acts that were to become enormously influential in the development of country music.

One was a former railroad brakeman who heard about the recording sessions by accident. "The Singing Brakeman," Jimmie Rodgers, went on to become known as "The Father of Country Music." The other was a family from Maces Spring, Virginia, who overcame two flat tires on the thirty-five-mile drive to Bristol. The Carter Family eventually recorded more than three hundred songs during the next fifteen years.

What began that day had a powerful impact on American music. Both Rodgers and the Carters sold millions of records and influenced

SUNDAY MORNING, JULY 24, 1927.

Don't deny yourself the sheer joy of Orthophonic music

A SMALL down-payment puts this great musical instrument in your home. Here is a source of entertainment for yourself and friends without end. You may have it now for a little cash and nominal monthly payments.

The Victor Co. will have a recording machine in Bristol for 10 days beginning Monday to record records—inquire at our Store.

Clark-Jones-Sheeley Co.

Victrolas — Records — Sheet Music
621 State St. Bristol, Va.

The New Orthophonic Victrola

untold numbers of country, rock, bluegrass, and folk musicians. Recognizing the seminal role played by the "Bristol Sessions," Congress officially designated Bristol as the "Birthplace of Country Music" in 1998.

Ralph Peer was an innovative producer who played an important role in what was then called "race music" (black artists) and "hillbilly music" (rural white artists). In 1920 he produced one of the very first blues records, Mamie Smith's "Crazy Blues." And in 1923, he produced what many consider to be the very first genuine country record, Fiddlin' John Carson's "Little Old Log Cabin in the Lane."

Jimmie Rodgers and the Carter Family. Rodgers's first recording session lasted two hours and twenty minutes. It took him seven takes to record two songs, "The Soldier's Sweetheart" and "Sleep, Baby, Sleep." The Carters recorded six songs over two days.

> **THE BRISTOL SESSIONS IS THE SINGLE MOST IMPORTANT EVENT IN THE HISTORY OF COUNTRY MUSIC.**
>
> —JOHNNY CASH

THE SONG THAT SAVED WHEATIES

A brand-new kind of commercial for a bran new cereal

On Christmas Eve, 1926, a barbershop quartet on WCCO radio in Minneapolis broke into song in what is believed to be the first singing radio commercial in history. For three years, the Wheaties Quartet, as they were known, appeared every week on the Minneapolis station, extolling the virtue of the new wheat bran cereal from General Mills.

But by 1929, the Wheaties brand wasn't looking too healthy. Sales, which hadn't exactly been overwhelming in the first place, dropped in half to a mere fifty thousand cases a year. The company called a special meeting to consider whether or not it was time to take Wheaties off the shelf.

The man who saved the cereal that day was a marketing guru named Sam Gale. He pointed out that three-quarters of the national sales for Wheaties were in just one city: Minneapolis. The only thing different in Minneapolis, the only possible explanation for the booming sales there, was the singing commercials of the Wheaties Quartet.

The members of the Wheaties Quartet included a court bailiff, a grain company executive, an undertaker, and a printer. They were paid twenty-four dollars a week (split four ways) to sing a fifteen-minute program of music that included the Wheaties jingle. Their pay improved when the commercials went national.

WHEATIES

WITH PLENTY OF MILK OR CREAM AND SOME KIND OF FRUIT

"The Breakfast of C...

Take them nationwide, Gale argued, and sales would follow.

The company decided to follow his advice. The Wheaties Quartet was renamed the Gold Medal Express (after General Mills' Gold Medal flour) and began appearing on network radio. Wheaties sales soared, and singing commercials soon became as common as, well, eating Wheaties for breakfast.

WHEATIES
WITH PLENTY OF MILK OR CREAM AND SOME KIND OF FRUIT
"The Breakfast of Champions"

Wheaties became the "Breakfast of Champions" in 1933. The following year, New York Yankees first baseman Lou Gehrig became the first of many athletes to appear on a Wheaties box.

> **" HAVE YOU TRIED WHEATIES?
> THEY'RE WHOLE WHEAT WITH ALL OF THE BRAN.
> WON'T YOU TRY WHEATIES?
> FOR WHEAT IS THE BEST FOOD OF MAN. "**
>
> —WHEATIES RADIO JINGLE

ONE-NIGHT STAND

One hit, no errors

Imagine a regular Joe is magically given one at bat in a major-league baseball game . . . just one . . . and he manages to hit a home run so spectacular it becomes known as one of the greatest hits of all time.

That comes pretty close to capturing the musical career of Stuart Gorrell.

Gorrell started out as a newspaperman, then went into banking. In thirty years at Chase Bank in New York, he worked his way up to assistant director of public relations and retired at age sixty. A pretty unremarkable career.

Except for that one night he got to write a song.

Gorrell was hanging out with his roommate, a former fraternity buddy at Indiana University who had started out as a lawyer, but was now in New York trying to make it as a musician. He had written a little piano tune, and on this one occasion in 1930, Gorrell was inspired to pitch in and write the lyric. It was the only time it ever happened.

The roommate was the soon-to-be-famous composer, actor, and bandleader Hoagy Carmichael. The song was

Carmichael penciled in Gorrell's name on the original lyric sheet. The words are ambiguous enough that the song could be about a place or a person. It is perhaps no coincidence that Hoagy Carmichael's sister happened to be named Georgia.

destined to become an American classic recorded by everyone from Ray Charles to Coldplay, just an old sweet song . . .

"Georgia on My Mind."

Gorrell also suggested the title of another Carmichael hit, "Stardust," saying the tune reminded him of "dust from stars drifting down through the summer sky."

"Georgia" really took off after Ray Charles recorded it in 1960. His version became a Grammy-winning number-one hit and eventually led to the composition being adopted as the state song of Georgia, even though it was written by two Indiana boys.

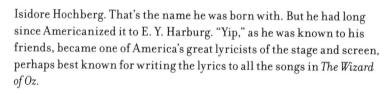

AN AMERICAN TUNE

*Rising from the
depths of the
Depression*

I sidore Hochberg lost everything in the Depression. The stock market crash wiped out his electrical appliance business. He was thousands in debt, with no way to support his wife and two children. "I found myself broke," he wrote. "All I had left was my pencil."

He decided to put that pencil to use. He called up a friend from high school and told him that he had decided to quit the business world forever and become a songwriter.

That may sound like a crazy move for a man facing financial ruin. But it just so happened that the old friend he confided in was famed lyricist Ira Gershwin, who told Hochberg it was about time he put his poetic talents to use. Gershwin introduced him to a composer named Jay Gorney, and the two began writing together.

Good move.

Isidore Hochberg. That's the name he was born with. But he had long since Americanized it to E. Y. Harburg. "Yip," as he was known to his friends, became one of America's great lyricists of the stage and screen, perhaps best known for writing the lyrics to all the songs in *The Wizard of Oz*.

Harburg had already written another set of lyrics for Gorney's tune, which was based on an old Russian lullaby. Called "Big Blue Tears," the song was about a woman crying over her lost man. But the songwriters were walking in Central Park one day when a hobo came up and said ,"Buddy, can you spare a dime?" Harburg quietly told Gorney he was going to rip up the old lyrics and write a new set.

> ## WHEN I LOST MY POSSESSIONS, I FOUND MY CREATIVITY. 99
>
> **—YIP HARBURG**

It is a striking fact that the financial disaster that devastated millions opened the door to Harburg's brilliant musical career. Even more remarkable, it also inspired one of his most powerful songs. Perhaps only a man whose life had been turned upside down by the Depression could have written the iconic anthem that captured its agony for all time.

"Brother, Can You Spare a Dime?"

More than ten thousand unemployed Pennsylvanians marched on Washington in 1932 at the height of the Depression demanding help. Harburg described the hero of his song in terms that would also fit them. "The man is really saying: 'I made an investment in this country. Where the hell are my dividends?' It doesn't reduce him to a beggar. It makes him a dignified human being." The song has been recorded by everyone from Rudy Vallee to Judy Collins.

> ## ONCE I BUILT A RAILROAD, MADE IT RUN, MADE IT RACE AGAINST TIME . . . BROTHER, CAN YOU SPARE A DIME. 99

HOT LIPPS STARTS A TREND

The birth of the
singing telegram

On July 28, 1933, a Western Union operator with the deliciously appropriate name of Lucille Lipps delivered the world's first singing telegram.

The idea was the brainchild of Western Union PR man George Oslin. America was in the middle of a crippling depression, and many people didn't have the money to send telegrams. Even worse, telegrams were closely associated with bad news—during World War I, the army used them to inform families of soldiers' deaths. Oslin wanted people to think of sending a telegram as something fun—so he cooked up a stunt.

He consulted a reference book, and discovered that one of America's biggest celebrities, Rudy Vallee, was about to celebrate his birthday. Oslin got his hands on the singer's phone number, then called the company's operations department. "I need a girl with the nerves of a brass monkey." Two minutes later, twenty-eight-year-old Lucille Lipps came to his office—and, yes, that was her real name.

For years Western Union had a corps of messengers who would deliver all sorts of different singing telegrams in person. Today they only do "Happy Birthday" singing telegrams, and only over the phone. But there are plenty of other companies who will have your singing telegram delivered by celebrity impersonators, belly dancers, cowboys, witches, or even a gorilla. That would be a Gorilla-Gram.

Lipps called Vallee on his birthday and gave him a rousing rendition of "Happy Birthday" over the phone. After she was done, there was dead silence on the other end of the line . . . followed by a dazed "thank you." Oslin gave the story to gossip columnist Walter Winchell, who put an item about it in his column the next day.

Senior management was furious. "I was angrily informed that I was making a laughingstock of the company," recalled Oslin. But their attitude quickly changed as the switchboards became jammed with people who wanted to send singing telegrams of their own. "It started America on a zany musical binge," said Oslin. And more than seventy-five years later, it is still going strong.

Rudy Vallee was a singer, bandleader, movie actor, and radio star. In 1933, he was one of the biggest celebrities in America. He dismissed the singing telegram birthday greetings as a publicity stunt, so it is ironic that singing telegrams are still around long after Vallee's popularity has faded.

A CLASS ACT

The hit born in a history class

James Morris was at wit's end about how to get his sixth-grade history class in Snowball, Arkansas, interested in the War of 1812. They tended to confuse it with the American Revolution and couldn't find any reason to care much about it.

So Morris wrote a song to help make the biggest battle of that war something his students could remember. Although he was a career teacher, he was a prolific songwriter and collector of songs, often singing tunes to friends and students.

More than twenty years later, in 1957, Morris was the principal of the Snowball, Arkansas, high school. A music store owner heard him sing his tune about the long-forgotten war and suggested he send it to a publisher in Nashville.

The next thing you know, fifty-year-old James Morris had a brand-new career. He changed his name to Jimmy Driftwood and began recording his songs. Others recorded them, too. Just two years later, in 1959, six songs he wrote were on the pop or country charts.

That song written twenty years before to teach his sixth-graders about history? "The Battle of New Orleans." Johnny Horton's recording of it shot to number one, won a Grammy in 1960 for Song of the Year, and has since become an American classic.

Jimmy Driftwood learned to play guitar at a young age on his grandfather's homemade guitar, which he used for his entire career.

A CORRECT VIEW of the BATTLE Near the City of NEW ORLEANS, on the Eighth of January 1815, Under the Command of Gen! And J Jackson, Over 10,000 British Troops, in which 3 of their most distinguish'd Generals were killed & several wounded and upwards of 3,000 of their choisest Soldiers, were killed; wounded, and made Prisoners. &c.

> **IN 1814 WE TOOK A LITTLE TRIP
> ALONG WITH COLONEL JACKSON
> DOWN THE MIGHTY MISSISSIP.
> WE TOOK A LITTLE BACON AND
> WE TOOK A LITTLE BEANS
> AND WE CAUGHT THE BLOODY BRITISH
> IN THE TOWN OF NEW ORLEANS.**

The Battle of New Orleans" has been recorded by hundreds of artists, including Johnny Cash, Lonnie Donegan, the Mormon Tabernacle Choir, the Nitty Gritty Dirt Band, and Pete Seeger.

REWRITING ROLLO

The beloved character born of a Christmas ad campaign

Robert May was searching for just the right name for his character. May was a copywriter for the department store Montgomery Ward. He was working on a Christmas story that the store could hand out to kids. His idea was to write a poem in the same rhyming style as "The Night Before Christmas," in which an unlikely hero named Rollo saved Christmas for Santa Claus. But Rollo didn't seem like quite the right name. He tried Reginald, but that didn't work, either.

Finally he hit on Rudolph.

May's rhyming story about "Rudolph the Red-Nosed Reindeer" wasn't an instant hit. His boss thought a Christmas character with a red nose was a no-no because he would seem like a drunk. But after he saw the charming illustrations by Denver Gillen, he agreed to go ahead.

Over the next six years, millions of copies were handed out by Montgomery Ward. But May himself wasn't doing so well. He was saddled by debt stemming from his wife's terminal illness. Montgomery Ward president Sewell Avery decided to give him the perfect Christmas present—the rights to Rudolph.

In 1949, his brother-in-law, composer John Marks, turned the tale into a song. Gene Autry recorded it the same year, and it became a big hit. Today more than 200 million recordings of the song by various artists have been sold, making it one of the most popular Christmas songs of all time.

Would it have worked as well if it were "Reginald the Red-Nosed Reindeer"?

The original Rudolph was a bit different from the character in the song or the popular animated special. He didn't live at the North Pole, but rather in a town full of reindeer who wore scarves and glasses and lived in houses. Santa discovered him accidentally one foggy Christmas Eve while delivering presents to the town and asked Rudolph to lead his team.

> " HA, HA! LOOK AT RUDOLPH! HIS NOSE IS A SIGHT! IT'S RED AS A BEET! TWICE AS BIG! TWICE AS BRIGHT! "

—A STANZA FROM MAY'S ORIGINAL POEM

Gene Autry was reluctant to record "Rudolph," but eventually agreed to do so because his wife liked it so much. His recording has sold more than 15 million copies.

CUTTING-ROOM FLOOR

Pay no attention to the man behind the curtain

After the first preview of *The Wizard of Oz*, the filmmakers decided to cut a song entitled "The Jitterbug," which takes place in the haunted forest. The only film footage left of the sequence is a grainy home movie taken on the set.

Another song was also cut after the first preview, because MGM studio boss Louis B. Mayer and other execs thought it was so painfully slow that it stopped the production cold. It remained on the cutting-room floor for preview after preview. Lyricist Yip Harburg said later that he and composer Harold Arlen "pleaded, begged, ranted [and] clamored" for the song to be reinstated—but to no avail.

At the last minute, a white knight appeared. Associate producer Arthur Freed took up the songwriters' cause with Mayer and convinced him to keep the song in. "Let the boys have the damned song," Mayer supposedly told him. "It can't hurt."

What was the song that was axed from the film, only to get a last-minute reprieve? None other than "Over the Rainbow," Judy Garland's signature number, winner of the Academy Award for best song, and voted the greatest movie song of all time by the American Film Institute.

A rescue worthy of the Wizard himself.

Louis B. Mayer.

Composer Harold Arlen (seated next to Judy Garland) didn't come up with the tune for "Over the Rainbow" until thirteen weeks into a fourteen-week contract. When he did, lyricist Yip Harburg (with his hands on Arlen's shoulders) hated it, because he didn't think it was right for the character. Eventually he came around. Also in the picture, but hard to recognize without makeup, Bert Lahr, the Cowardly Lion (far left), and Ray Bolger, the Scarecrow (standing next to him).

Actor Buddy Ebsen was originally slated to play the Tin Man, but the aluminum dust used in his makeup made him seriously ill, and he was replaced by actor Jack Haley. Ebsen's voice can still he heard on the sound track in the song "We're Off to See the Wizard."

Arthur Freed, the associate producer who saved the song, was himself a lyricist. His best-known song: "Singin' in the Rain."

A SOLDIER'S SONG

The wartime hit that knew no boundaries

In 1941, a German army radio station in Belgrade sent out a soldier to scrounge for more records to play for the troops. He brought back a dusty box of discards from the basement of a Vienna radio station. One was "Song of a Young Sentry," recorded by Lale Anderson. A sentimental song about a soldier missing his girl, it was a complete flop when released in Germany two years before, selling only seven hundred copies. But the director of the station was so desperate for more music to play that he put it on the air anyway.

German soldiers in North Africa began writing in by the thousands, demanding that the obscure song be played more often. They didn't know the title, so they referred to it by the name of the soldier's girlfriend.

Lili Marlene.

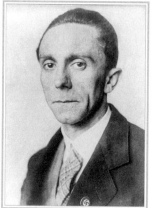

But it wasn't only the German soldiers who liked it. British soldiers fighting the Germans in North Africa also fell in love with the song, even though most didn't know the words. The radio station started playing it every night just before sign-off, and many veterans later claimed that the firing diminished at that hour as soldiers on both sides listened to the song.

Nazi propaganda minister Joseph Goebbels hated the song because its sentimentality seemed to contain an antiwar message. He ordered the song banned from civilian radio, writing that "a dance of death lingers between its bars." He attempted to keep it off German military radio as well, but the desire of the soldiers to hear it proved too strong.

Its popularity kept spreading, and "Lili Marlene" went from the discard box to becoming the soldiers' favorite song of World War II. Translated into many languages, it had universal appeal to millions of homesick soldiers of many countries locked in mortal combat with one another. As one German wrote: "Soldiers can die, but an evening without 'Lili Marlene' is unthinkable."

Concerned that a German song was so wildly popular with British soldiers, the British government commissioned a translation that was written by Tommy Connor, who also wrote "I Saw Mommy Kissing Santa Claus." The Brits also made a propaganda film explaining how the British had "captured" the song. This is a promotional still from that film, The Truth About Lili Marlene.

> ## " CAN THE WIND EXPLAIN WHY IT BECAME A STORM? "

—LALE ANDERSON TRYING TO EXPLAIN THE POPULARITY OF "LILI MARLENE"

The original words are from a poem by a World War I soldier named Hans Leip. Norbert Schulze set the words of the poem to music in 1937. Dozens of German record companies turned down the song, saying the public was looking for more martial music, before one company agreed to record it.

GADZOOKS!

The jazzy weapon that helped win World War II

Sergeant Bob Burns was a championship rifleman in the Marine Corps during World War I. But as good a marksman as he was, he was a better musician. Burns organized a Marine Corps Jazz Band that was a favorite of General John Pershing and played to troops across Europe.

Burns was especially well known for playing an instrument that he invented himself. It was made out of two pieces of gas pipe and a whiskey funnel. It was sort of a combination of a trombone and a slide whistle, and it became Burns's trademark. He even coined a funny name for it.

After the First World War, Burns became a radio entertainer and a movie star. He was known around the country as the "Arkansas Traveler," casting himself as a homespun rube telling tales of the Ozarks. But the cornerstone of his success was that wacky instrument of his. In the late 1930s and early 1940s, at the height of his popularity, thousands of toy versions were manufactured and sold to kids across America.

Burns's instrument is forgotten today, but the name he dreamed up for it lives on—with a very different meaning.

In the early days of World War II, the army was testing a new shoulder-mounted antitank gun called the M1A1 at the Aberdeen Proving Ground. The soldiers trying it out thought that it bore a remarkable resemblance to

Burns's bazooka sounded like a low-toned saxophone with a range of about six notes. Burns was equally adept at playing the instrument for laughs or turning in virtuoso jazz performances with it.

the odd contraption Burns had made famous. And so it got the nickname by which it is still remembered.

The bazooka.

Where did Burns get the name? He said once that he took it from the now-obsolete slang word "bazoo," meaning mouth, as in "he blows his bazoo" (meaning he talks too much). He told other people the name mimicked the sound his instrument made.

The United States manufactured nearly half a million bazookas during World War II, along with 15 million of the antitank rockets it fired. The bazooka was so successful at stopping enemy tanks that the Germans copied it outright. They did, however, give it another name, calling it the Panzerschreck, or "tank terror."

TO PLAY HIS BAZOOKA HERE

Jazz Band Sergeant Introduces New Gas Pipe Tone-Teaser.

Sergeant Robert Burns, who organized General Pershing's Jazz Band during the war. has introduced a new musical instrument for dance music here. Burns has just arrived from London with his unique instrument, which he calls the bazooka. It has much the same tone as a deep-toned saxaphone, and consists of two pieces of gaspipe, to which are attached funnellike ends.

The instrument is the result of Burns's ingenuity during the war, when musical instruments of all kinds were so greatly needed and the crude material was all that could be found in the emergency.

Stars and Stripes article from World War II mentioning Burns and his bazooka.

HIGH SCHOOL MUSICAL

In which "terrible" is the prelude to greatness

Lyricist Oscar Hammerstein is one of the towering figures of musical theater. He is famous for collaborating with Richard Rodgers on such legendary musicals as *Oklahoma*, *The King and I*, and *South Pacific*.

In the spring of 1945, a friend of Hammerstein's teenage son Jimmy brought Hammerstein a musical review he had written about campus life. The fifteen-year-old boy had been showered with praise by classmates for the production "By George," and he was convinced Hammerstein would like it so much he would want to produce it right away.

Not exactly.

"It's the worst thing I ever read," Hammerstein told the boy, who stood there in shock. Then Hammerstein continued: "If you want to know why it's terrible, I'll tell you." Hammerstein spent the rest of the day going through every scene, every song, every line of dialogue with the teenager, picking apart every detail.

Some might find such an exercise an unbearable humiliation, but the boy was made of stronger stuff. "In that afternoon," he recalled years later, "I

Sondheim's musical training was minimal: a year of piano when he was seven, a year of organ when he was eleven, and two more years of piano as a teenager.

learned more about songwriting and the musical theater than most people learn in a lifetime."

Oscar Hammerstein won eight Tony Awards. The young man he painstakingly critiqued that day has won eight Tonys as well for musicals such as *West Side Story*, *A Little Night Music*, and *Sweeney Todd*. At age eighty (in 2010) he's become a Broadway legend of his own.

Stephen Sondheim.

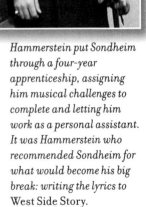

Hammerstein put Sondheim through a four-year apprenticeship, assigning him musical challenges to complete and letting him work as a personal assistant. It was Hammerstein who recommended Sondheim for what would become his big break: writing the lyrics to West Side Story.

ANGRY ANGUS

The forgotten political campaign that produced a legendary song

I n a ripsnorter of a campaign, Jack Hynes beat out James Michael Curley for mayor of Boston in 1949. The legendary Curley had spent four terms in the mayor's office, but after this election he would be the man who never returned. Gaining almost no attention at all was a left-wing union organizer named Walter O'Brien, who came in dead last among five candidates, with just 1 percent of the vote.

Yet he's the one we remember today.

O'Brien's big issue involved a government takeover. Boston's subways and trolley were run by the Boston Elevated Railway, a private company. When it went belly-up in 1947, the state created the Metropolitan Transit Authority, which bought the company for $20 million, then raised fares to pay for it—customers had to pay an extra nickel when they got off the trolley. O'Brien charged that it was a corrupt bailout for the fat cats laid on the backs of the workers.

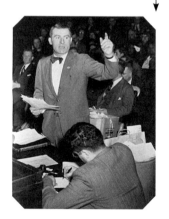

A group of folkies supporting O'Brien got together in Cambridge one Sunday night to write campaign songs for him. One of their efforts—a "throwaway," coauthor Jackie Steiner later called it—was about a man named Angus who couldn't afford the fare increase and ended up trapped on the subway. But Angus didn't quite fit as the name of their "everyman" rider, so they changed it.

To Charlie.

O'Brien ran as the Progressive Party candidate. During the McCarthy era, he found himself hounded by the FBI for what were considered radical political views. He eventually moved to Maine, where he became a librarian.

Walter O'Brien is long forgotten. But Charlie is forever with us, riding all night long beneath the streets of Boston, waiting for that "one more nickel" that will finally get him off the M.T.A.

According to the most famous verse in the song:

Charlie's wife goes down to the Scollay Square station
Every day at quarter past two,
And through the open window she hands Charlie a sandwich
As the train goes rumbling through.

Generations of fans have asked why she didn't slip a nickel in there. Sam Berman has the answer: "Because if she had, there wouldn't have been a song."

In 2004 the M.B.T.A., as it is now called, named its subway fare card the "Charlie Card."

The group that originally recorded the song, as well as six other songs written for the O'Brien campaign, called themselves "The People's Artists." From left to right: Al Katz, Arnold Berman, Jackie Steiner, and Sam Berman (who sang vocals). The song was written by Steiner and Beth Lomax Hawes (daughter of Alan Lomax). It was another decade before the Kingston Trio recorded the version that became a hit, changing the name of the candidate to "George O'Brien" to avoid political controversy.

The music for the song was taken from an 1865 song by Henry Clay Work called "The Ship That Never Returned." It's also the music used in "The Wreck of the Old 97."

THIS *IS* YOUR FATHER'S OLDSMOBILE

The birth of Rock(et) and Roll

In 1949, Oldsmobile introduced the Rocket 88. With its souped-up V-8 engine and streamlined design, it soon became the hottest thing on the road, a high-performance car like no one had ever seen before.

It also inspired what some historians call the very first rock 'n' roll song.

Ike Turner had a Mississippi blues band called the Kings of Rhythm when he got a call from a struggling twenty-eight-year-old Memphis record producer named Sam Phillips. Phillips invited the band to record some songs. In March 1951, Turner and his band tied their gear on the roof of an old Chrysler and headed out from Clarksdale, Mississippi, to Memphis.

Smooth sailing when you ride the "Rocket"! *SUPER*

OLDSMOBILE "88"

Needing more material for their recording session, Turner and his bandmates wrote a new song en route about the hot new car they all envied. In Memphis, they recorded several songs, getting paid twenty-five dollars for each one. On "Rocket 88," Phillips suggested saxophonist Jackie Brenston sing the lead, while Ike Turner banged away on the piano.

The fruit of their efforts was a rollicking, high-energy song that Phillips sold to Chess Records. Credited to Jackie Brenston and His Delta Cats, it spent five weeks at number one on the R&B charts and proved to have great crossover appeal for white audiences as well. It

Oldsmobile stopped producing the 88 in 1999, and the Olds brand itself was discontinued in 2010. Rock 'n' roll keeps on going.

helped put Sam Phillips on the map and paved the way for his founding of Sun Records and the discovery of Elvis Presley.

Thanks to the Rocket, rock 'n' roll was ready to blast off.

Anyone could walk in the door of Phillips's Memphis Recording Service and plunk down two dollars to record a song. In the summer of 1953, an eighteen-year-old truck driver with a dime-store guitar came in to do just that. His name was Elvis Presley. Something about the way he sounded convinced Phillips to bring him back the following year for a more serious recording session. It didn't prove very productive until Elvis and the other musicians started fooling around between takes on a song called "That's Alright, Mama." Phillips asked what they were doing and they said they didn't know. "Well, back it up, try to find a place to start, and do it again." Two nights later, the song was being played on Memphis radio, and Elvis was on his way.

Kings of Rhythm guitarist Willie Kizart's speaker had been damaged by the drive, so Phillips stuffed some paper in the cone. That resulted in a slight distortion that seemed to add to the sound, and foreshadowed the fuzz and distortion that would become big in the 1960s.

> **ROCK 'N' ROLL IS NOTHING BUT BOOGIE-WOOGIE WITH PAINT ON IT. IF YOU'RE BLACK IT'S R&B, IF YOU'RE WHITE THEY NAME IT ROCK 'N' ROLL. TO ME IT WAS JUST ANOTHER SONG.**

—IKE TURNER

LEGACY OF LINCOLN

The symphony that helped sink a dictator

Six thousand people crowded the hall in Caracas to see composer Aaron Copland conduct the Venezuela Symphony Orchestra. They were performing Copland's "Lincoln Portrait," in which a narrator reads the stirring words of Lincoln along with Copland's powerful music. One of those in attendance was Venezuela's military dictator Marcos Pérez Jiménez, whose regime was notorious for its brutality.

A fiery actress named Juana Sujo spoke a translation of Lincoln's words to the hushed crowd. The piece ends with the final words of Lincoln's Gettysburg Address, "that government of the people, by the people, for the people, shall not perish from the earth." As Sujo spoke the translation, "del pueblo, por el pueblo y para el pueblo," the crowd leaped to its feet and cheered so wildly that Copland couldn't hear the orchestra play the final few bars of the music.

A *New York Times* reviewer said the piece had a "magical impact" on the audience. The impact on dictator Jiménez was particularly powerful. The thundering crowd's full-throated roar was the first public protest against his military dictatorship. Copland was told later that his piece had, in effect, started the revolution. Less than nine

Copland wrote the piece in 1942, shortly after the United States entered World War II. He was one of three composers commissioned to create musical portraits of great Americans by conductor André Kostelanetz. "I want people to get the message of what democracy is, what we are fighting for." Copland originally chose Walt Whitman but was persuaded to tackle Lincoln instead.

months later the dictator was out, and Venezuela had a new birth of freedom—thanks in some small part to a night at the symphony.

Jiménez came to power in 1952. He ordered opponents murdered, closed the universities, abolished unions, and clamped down on the press. He was later tried for his crimes and exiled to Spain.

JUST BLOWING HIS HORN

The day Satchmo
spoke out

In the 1950s, Louis Armstrong was one of the most famous entertainers in America. But when it came to the struggle for civil rights, he kept a low profile. Some criticized him for not taking a stand. "I don't get involved with politics," he responded. "I just blow my horn." He didn't take part in protests or speak out.

Until the day he finally did.

In September 1957, Arkansas governor Orval Faubus mobilized the Arkansas National Guard to prevent nine black students from integrating Little Rock's all-white Central High School. The confrontation rocked the nation. Many called on President Eisenhower to do something, but weeks went by with little action.

In the midst of the crisis, Armstrong was scheduled to play in Grand Forks, North Dakota. An enterprising cub reporter named Larry Lubenow snuck into his hotel room to interview him. When he asked about Little Rock, Armstrong's smiling face clouded with anger. "The way they are treating my people in the South, the government can go to hell," he said. He called Eisenhower "two faced" and "gutless," and said he was pulling out of a planned goodwill concert tour of the Soviet Union on behalf of the government. "The people over there ask me what's wrong with my country. What am I supposed to say?"

His angry remarks echoed around the globe. The world took note that the normally affable Satchmo had spoken out at last.

on't Take Back a Thing I've Said!'

atchmo' Tells Off Ike, U. S.!

strong

Rias

he belongs. Everything Tal-
lerie said he made it up with
that newspaperman without
my signature.

and the w
has misl
"My p

Turns D

"Mr. Armstrong's words had the explosive effect of an H-Bomb," said a newspaper in Amsterdam. And they may have helped tip the balance. A week later Eisenhower sent the 101st Airborne to Little Rock to integrate Central High.

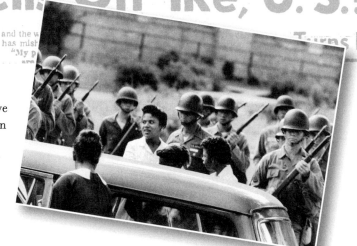

" IT'S GETTING SO BAD A COLORED MAN HASN'T GOT A COUNTRY. "

—LOUIS ARMSTRONG TO LARRY LUBENOW

After Eisenhower sent the 101st to Little Rock, Armstrong sent him a note: "If you decide to walk into the school with the little colored kids, take me along, Daddy." After the crisis was over, the jazzman praised the president's handling of race relations. "He has done as much as Lincoln did and more than any other president between them."

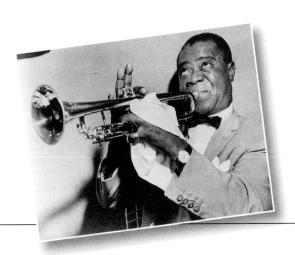

IF I NEEDED SOMEONE

A match made in rock 'n' roll heaven

Chances are that you have never heard of Ivan Vaughan. Nevertheless, he is arguably the most important person in the history of rock 'n' roll. He has changed the lives of billions of music fans across the world. The pop music landscape might look very different if not for what a teenaged boy named Ivan Vaughan did one Saturday afternoon.

It happened on a July day at a church fair in the British village of Woolton. The parade had gone off without a hitch, the Rose Queen had been crowned, and the visiting police dogs had duly impressed the parishioners of St. Peter's.

In the church hall, a local skiffle band called the Quarrymen, which Vaughan sometimes played for, was rehearsing for the "Grand Dance," which would cap the festivities. Vaughan brought a friend (who had ridden over on his bike) to introduce him to the bandleader, who was decked out in an outrageously loud red-checked shirt. Vaughan's exact words are lost to history, but they probably went something like this:

"John, I'd like you to meet my friend Paul. Paul, this is John. I think you guys would get along."

In a church in suburban Liverpool, fifteen-year-old Ivan Vaughan introduced his school chum Paul McCartney to his

This picture of the Quarrymen was taken by the father of band member Rod Davis (far right) shortly before Paul was introduced to the group. They are on a flatbed truck in the Rose Queen parade, headed toward the church where the fateful meeting will take place. John Lennon, in his checked shirt, is seated with his eyes closed.

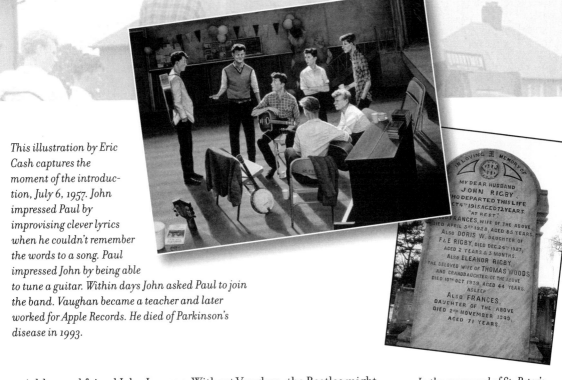

This illustration by Eric Cash captures the moment of the introduction, July 6, 1957. John impressed Paul by improvising clever lyrics when he couldn't remember the words to a song. Paul impressed John by being able to tune a guitar. Within days John asked Paul to join the band. Vaughan became a teacher and later worked for Apple Records. He died of Parkinson's disease in 1993.

neighbor and friend John Lennon. Without Vaughan, the Beatles might never have happened. Instead, Lennon and McCartney would go on to make music history . . . with a little help from one of their friends.

In the graveyard of St. Peter's Church, where John met Paul, there just happens to be a stone marking the final resting place of a woman who died in her sleep at age forty-four: Eleanor Rigby.

John was raised by his aunt Mimi, and when she bought him his first guitar, she told him: "The guitar's all right, John, but you'll never make a living with it." Turns out, he did OK.

ALL THAT JAZZ

First time's the charm

During his thirty-five-year career as a photographer, Art Kane photographed legions of rock stars, including Bob Dylan, Janis Joplin, and the Who. He shot many celebrated photos for *Life*, *Look*, *Rolling Stone*, and other magazines. But it was the very first photo he took as a professional that became a music legend.

Esquire magazine was doing an all-jazz issue and gave Kane a chance to shoot a picture for it. Kane was already an award-winning art director, but he was itching to try his hand as a photographer. He got the crazy notion of assembling every living jazz great within reach for the photo. Since he didn't have his own studio, he proposed doing it on a stoop in Harlem.

No one had ever tried to gather so many jazz greats together at one time. Kane put out the word everywhere he could and hoped people would show. It was a risky gamble, especially with the shoot scheduled for 10 a.m.—an hour when those night-owl musicians would normally be still sleeping.

Naysayers told Kane he would be lucky to get a dozen people. But when the August morning rolled around, an incredible fifty-eight jazz legends showed up at the house on 126th Street. Kane twisted a *New York Times* into the shape of a megaphone and tried to coax the musicians into position. "To try to control this group was almost impossible," he said. But eventually he got them together long enough to push the button.

The photograph Kane snapped that day—*Harlem 1958*—became a jazz icon. "The history of jazz in one picture," as jazz pianist Hank Jones described it.

Not bad for your first time.

Art Kane.

One of the musicians joked that he was astonished to discover that morning that there were two 10 o'clocks in each day.

Fifty-eight musicians showed up, including Dizzy Gillespie, Thelonious Monk, and Count Basie. Basie wearied of standing and decided to sit down on the curb. When he did so, a bunch of neighborhood kids did the same thing—and thus wormed their way into the picture. One other musician, Willie "The Lion" Smith, got tired and left the group—missing his chance to be in the iconic shot.

> 66 I CAME UP WITH THIS REALLY OUTRAGEOUS IDEA, AND WATCHING IT UNFOLD THE WAY I'D THOUGHT OF IT . . . WAS MAGNIFICENT. I KNEW FROM THAT MOMENT ON THAT THIS WAS WHAT I WANTED TO DO WITH MY LIFE. I WANTED TO BE A PHOTOGRAPHER. 99

—ART KANE

WHAT'S THAT FUZZ?

The accidental invention of a signature rock 'n' roll sound

Country singer Marty Robbins was in a Nashville studio recording the song "Don't Worry." Legendary sideman Grady Martin, who played for everyone from Elvis Presley to Bing Crosby, was accompanying him on a six-string bass.

But when engineer Glen Snoddy played back their performance, a blown transformer in the mixing board caused the bass to sound strangely fuzzy and distorted. They decided to leave it that way, and the song went on to become a number one hit.

Snoddy saved the malfunctioning channel on the mixing board, and brought it out when others wanted the same effect. When it finally died, "I set about trying to develop that sound using transistors."

Snoddy took his new invention to Gibson Guitar in 1962, and so was born the "Maestro Fuzz Tone," the very first guitar effects box. Gibson advertised it as something that could make an electric guitar sound like a cello or a horn section. The company manufactured five thousand units, but they didn't exactly fly off the shelves.

One twenty-two-year-old guitarist who bought one thought it sounded pretty gimmicky, but decided to use it on a new song anyway. The guitarist was Keith Richards of the Rolling Stones, and the song was "Satisfaction," destined to become the band's breakout hit and one of the greatest rock 'n' roll songs of all time. After it hit number one, Gibson sold out its entire stock of fuzz-boxes . . . and fuzz guitar became the new sound of rock.

Oct. 19, 1965 G. T. SNODDY ETAL 3,213,181
TONE MODIFIER FOR ELECTRICALLY AMPLIFIED ELECTRO-MECHANICALLY
PRODUCED MUSICAL TONES
Filed May 3, 1962

INVENTOR
Glen T. Snoddy
Revis V. Hobbs
BY
ATTORNEY

"Satisfaction" features the most famous guitar riff in music history. On the night of May 9, 1965, Keith Richards awoke from a sound sleep in a Florida hotel room with the riff running through his mind. He turned on a tape recorder and recorded it, then went back to sleep, leaving the tape recorder running (and recording his snoring). By morning he had forgotten everything and had to rewind the tape to remember what he had done. He and Mick Jagger wrote the rest of the song the same day, and the Stones recorded it a week later.

> **IF I HAD MY WAY, 'SATISFACTION' NEVER WOULD HAVE BEEN RELEASED. THE SONG WAS AS BASIC AS THE HILLS AND I THOUGHT THE FUZZ GUITAR THING WAS A BIT OF A GIMMICK. SO WHEN THEY SAID THEY WANTED IT AS A SINGLE, I GOT UP ON MY HIND LEGS FOR THE FIRST TIME AND SAID, 'NO WAY.'**

—KEITH RICHARDS, WHO WAS OVERRULED BY HIS BANDMATES

THE ANNIVERSARY WALTZ

The secret life of Doc Pomus

When Jerry Felder heard a record by the great blues artist Big Joe Turner, he decided that he too wanted to be a blues singer. The fact that he was a white Jewish kid from New York wasn't going to stand in his way of getting into what was almost exclusively an African American genre. At age sixteen, he started performing in blues clubs under the name "Doc Pomus."

Doc started songwriting to make money between gigs, and the songwriting eventually proved more lucrative than the blues singing. He teamed up with composer Mort Shuman, and their partnership resulted in such hit songs as "Teenager in Love," "This Magic Moment," and "Viva Las Vegas."

But there was one song that was much more personal, more searing, than all the rest.

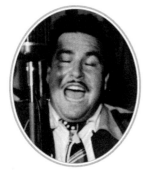

He wrote the lyrics late one night on the back of an old wedding invitation, recalling the day three years earlier that he married Broadway actress Willi Burke. It was a joyful occasion, but there was one moment tinged with a taste of the bittersweet. It was the moment after the band struck up a tune, when the bride and groom traditionally have the first dance.

As a child, Doc Pomus had been crippled by polio. He could walk only with great difficulty. As a blues singer, he had to hang on his crutches while singing. Dancing was out of the question. At his wedding, he urged Willi to dance with the other guests. He could only watch, with mixed emotions, as she twirled across the floor without him.

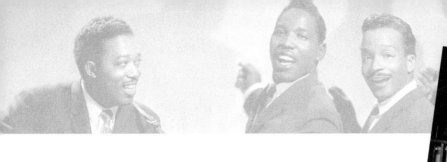

It was with that memory in mind that Doc scrawled a set of lyrics revealing his most vulnerable inner self. The heartfelt plea of a man who couldn't dance to the beloved bride just out of his reach . . .

Don't forget who's taking you home
And in whose arms you're gonna be
So, darling, save the last dance for me.

> ## I WAS GOING TO DO SOMETHING TO SHOW THE WORLD THAT I COULD COPE WITH MY HANDICAP AND BE A MAN AMONGST MEN.

—DOC POMUS ON HIS BLUES CAREER

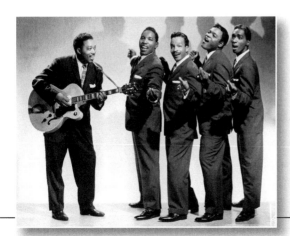

"Save the Last Dance for Me" became a number-one hit by the Drifters in December 1960. It has since been recorded by numerous others, including Tina Turner, Bon Jovi, Bruce Springsteen, Dolly Parton, actor Bruce Willis, and Petula Clark—in French!

The Drifters' version of "Save the Last Dance for Me" was produced by Jerry Leiber and Mike Stoller, with the help of a then-unknown apprentice named Phil Spector. Spector, of course, went on to become an acclaimed record producer before eventually going to prison for murder in 2009.

LISTEN TO THE MUSIC

Unintelligible at any speed

In early 1964, the FBI began a thirty-month investigation that would draw in field agents across the country. They interviewed dozens of witnesses and compiled hundreds of pages of documents. Even the FBI crime lab got into the act. What was the purpose of this massive effort?

They were trying to understand the lyrics of a popular song.

When the Seattle band the Kingsmen recorded "Louie Louie," lead singer Jack Ely was wearing braces on his teeth and standing on tiptoe to sing into an overhead microphone. The result was that almost nobody could understand the words he was singing. Rumors began spreading that the song was filled with dirty words. The governor of Indiana proclaimed "Louie, Louie" to be pornographic and tried to ban its radio play. Then the FBI swung into action.

Agents threatened the writer of the song, Richard Berry, with jail. They interviewed the producer and members of the band. They interviewed a rival band, Paul Revere and the Raiders, that also recorded the song. They collected various sets of suggestive lyrics, each of which was said to be the "real" version. The crime lab speeded the record up and slowed it down, but in their report: "none of the speeds assisted in determining the words."

The record first hit the charts when legendary DJ Arnie "Woo Woo" Ginsburg played it as the "Worst Record of the Week" on WMEX in Boston. The fans liked it better than he did.

"Louie Louie" is a sea chantey about a homesick Jamaican sailor telling the bartender about his girl back home. Nothing dirty about it. But the FBI investigation (which eventually petered out) and the controversy surrounding the song helped it to become one of the most popular rock 'n' roll songs of all time, with a mystique that has never quite left it.

Thank you, J. Edgar Hoover.

Richard Berry wrote the song in 1956, scribbling down the lyrics on a paper bag in the dressing room at Harmony Park Ballroom in Anaheim, California. He got the idea for the tune from a song called "El Loco Cha Cha" by Rene Touzet. This picture of him was taken in 1991.

What song kept "Louie Louie" from becoming number one on the *Billboard* charts in January 1964? It was Sister Luc Gabrielle, the Singing Nun, singing "Dominique." A clear case of proven piety conquering possible prurience. Or something.

DREAM ON

Does anybody really know whose song it is?

Paul McCartney woke up one morning with a tune running through his head. A jazz tune, he thought, like the songs his father used to play. He hummed it for friends, trying to figure out where he had heard it before.

He made up nonsense words so he could sing it to people. "Scrambled eggs, oh baby how I love your legs." No one seemed to know where the tune came from. After a few weeks of this he decided that it must be his. "Like a prospector I finally staked my claim," said McCartney. "I stuck a little sign on it and said, 'Okay, it's mine!'"

He wrote lyrics and brought it to the studio. But it didn't feel much like a Beatles song to his bandmates. Ringo tried to play drums on it, but they didn't feel right. John Lennon experimented with adding an organ part, but that didn't work, either. Eventually McCartney recorded two takes of the song alone, accompanying himself on a guitar, and producer George Martin added a string quartet.

It wasn't rock 'n' roll, exactly, but it was pure gold.

The tune that came to Paul McCartney while golden slumbers filled his eyes was "Yesterday," which has since become the most recorded song in history and also has been voted the number-one pop song of all time in several polls.

Dreams don't come much better than that.

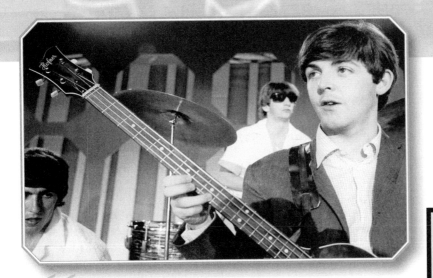

> " **DO YOU KNOW THIS? IT'S A GOOD LITTLE TUNE, BUT I COULDN'T HAVE WRITTEN IT, BECAUSE I DREAMT IT.** "

—PAUL MCCARTNEY TO HIS FRIENDS

John Lennon recalled being in a restaurant in Spain with Yoko when a violinist came to their table, played "Yesterday" with a flourish, and then asked John to autograph his violin. "One day he's going to find out that Paul wrote it," Lennon told an interviewer. "But I guess he couldn't have gone from table to table playing 'I Am the Walrus.'"

It is estimated that more than three thousand artists have recorded "Yesterday," but one missed the chance to be first. In 1965, Paul McCartney offered the as-yet-unrecorded song to British singer Billy J. Kramer, who turned it down as being too soft.

THANKS, COACH

Hair today, fame tomorrow

The basketball coach had a reputation—and he knew it. "Very demanding, hard-nosed, and probably not on the list of most popular teachers in those days" is how he described it later. It might have been the swinging sixties elsewhere, but Robert E. Lee High School in Jacksonville, Florida, had rules about how long a boy's hair could be. It couldn't touch the back of the shirt collar. And the coach was one of those charged with enforcing the rules.

Students would grease up their hair to hide how long it was, but the coach would catch them after they had just showered and send them to the assistant principal's office. Gary Rossington remembered getting caught dozens of times and finally being suspended for it.

Gary's buddies thought this was hysterical. They were all in a band called My Backyard, pumping out rock tunes at dances. Then they changed the name to Noble 5 and then to One Per Cent, after patches they had seen tattooed on Hells Angels bikers in a movie.

Right before a concert, somebody laughingly suggested they

When the band became big, Skinner (left) barely remembered them, and certainly didn't care much for their music. "I had the album," recalls his son, "and he'd say, 'What the hell kind of noise are you listening to?'" But he eventually embraced his namesake, introducing them at a concert and allowing them to use a sign from his real estate company on one of their album covers.

should name the band after the coach who was always riding them. After all, everyone in school would get the joke. And so they did.

Coach Leonard Skinner.

And that's how the southern-rock band Lynyrd Skynyrd got its name. The band went on to sell more than 30 million albums with hits like "Sweet Home Alabama" and "Free Bird."

Robert E. Lee High School

Founder Ronnie Van Zant and two other band members were killed in an airplane crash in 1977. The band re-formed in 1987. Today Gary Rossington is the only original member.

ADVENTURE CAPITAL

Reality television with an unexpected twist

Here's an idea for a sitcom: Two naive young venture capitalists with more money than brains keep getting themselves involved with crazy business ventures. Humorous escapades follow.

John Roberts and Joel Rosenman planned to pitch that very concept to a TV network. To help flesh out their idea, they ran an ad in the *Wall Street Journal*:

> *Young men with unlimited capital looking for interesting, legitimate investment opportunities and business propositions.*

Thousands of responses poured in. Many were pretty wacko. But others seemed to be worth investing in. And the pair had access to money—Roberts's grandfather founded the company that made Polident Denture Adhesive, and he could borrow against his trust fund. So they began to look into some of the proposals.

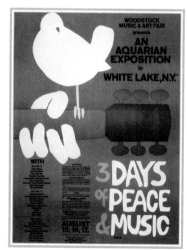

"Somehow, we became the characters in our own show," Rosenman said.

One contact led to another, and eventually the two fledgling investors met with a couple of guys who wanted to build a recording studio in upstate New York. Part of their plan was to have a cocktail party to publicize its opening. It was suggested that local artist Bob Dylan might attend.

Dylan? That got Robert and Rosenman excited. Forget about the recording studio, what if they could get Dylan to

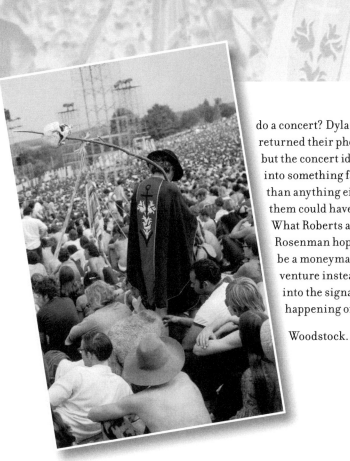

do a concert? Dylan never returned their phone calls, but the concert idea evolved into something far bigger than anything either of them could have imagined. What Roberts and Rosenman hoped would be a moneymaking venture instead turned into the signature happening of the era.

Woodstock.

The influx of people was so massive that the organizers had to give up the idea of charging for tickets. The final crowd was estimated at half a million. By the time the three-day festival was done, the organizers were more than a million dollars in the hole. But money for the movie rights brought them close to breakeven, and licensing of the logo eventually enabled them to do what Woodstock was supposed to do in the first place: make a profit.

One of the ideas that came in response to the ad was a proposal to import "Ski-Bobs"— bicycles on skis instead of wheels. Had that worked out, they might have become the Ski-Bob kings, and Woodstock might never have happened.

THE KING AND I

When legends collide

It was just another Monday morning at the White House when an unannounced visitor walked up to the front gate and announced that he wanted to meet with President Nixon. Normally, such people are given the brush-off, but this one was treated differently.

It was "The King." Elvis Presley.

The famous singer dropped off a six-page handwritten letter requesting a meeting. Nixon adviser Bob Haldeman decided to give him an appointment with the president the very same day.

Their brief get-together in the Oval Office was surreal. Presley told the president earnestly that he had been studying Communist brainwashing and the drug culture for over a decade. He asked Nixon to make him a "federal agent at large" to help fight the spread of drugs. (Especially ironic, given that Presley was a chronic drug abuser who eventually died of an overdose.)

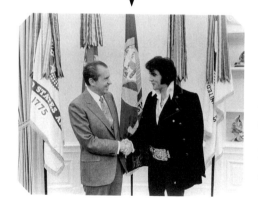

He also offered the surprising observation that the Beatles were a major source of anti-American spirit, and their music was filled with anti-American themes.

As the meeting drew to a close, Presley seemed gripped by emotion as he told the president that he was "on your side." Then he surprised the normally aloof Nixon by giving him a bear hug.

The next thing you know, Elvis had left the building.

AmericanAirlines

In Flight....

Altitude: _____

Location: _____

Dear Mr. President:

First I would like to introduce myself. I am Elvis Presley and admire you and Have Great Respect for your office. I talked to Vice President Agnew in Palm Springs 3 weeks ago and expressed my concern for our country. The Drug Culture, The Hippie Elements, the SDS, Black Panthers, etc. do not consider me as their enemy or as they call it the Establishment. I call it America...

Mr. President
NUMBERS
These are all my pvt numbers
Beverly Hills 278-2496
278-5935
Palm Springs 325-3241
Pvt #
Memphis 397-4427
398-4882
398-9722
Pvt. #
Col. P.S. # 325-4781
Col. B.H. # 274-8498
Col. Off. Mem 870-0370

WASHINGTON HOTEL / PHONE ME 85900
Rm 505-506.
UNDER THE NAME OF JON BURROWS

PRIVATE AUD CONFIDENTIAL

Atten, President Nixon
via Sen George Murphy
from
Elvis Presley

Presley scrawled his letter requesting an appointment with the president while on a cross-country flight.

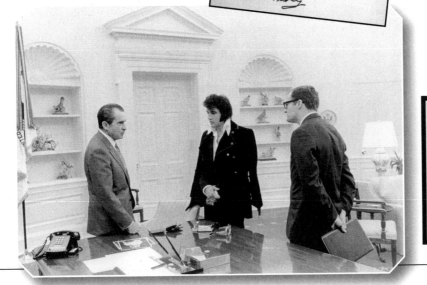

In response to Presley's request, the White House arranged for him to get a Bureau of Narcotics badge with his name on it.

A BRONX TALE

The birth of hip-hop

It began with a party in a South Bronx high-rise, in the summer of 1971. Cindy Campbell begged her sixteen-year-old brother Clive to spin records for it. They charged twenty-five cents a head for girls, fifty cents for boys. It was a big success, and Clive started DJing at more parties.

Clive and his family had come to the United States from Jamaica. A big kid, his friends called him Hercules. Soon he began calling himself Kool Herc. He had two turntables, to play one song after another, but sometime around 1973 he started doing something different. He would take two copies of the same record and put one on each turntable. Then he could take his favorite instrumental break in a song and play it over and over in a continuous loop. Sometimes he would recite bits and pieces of rhymes over the instrumentals, or let other people come up and try their hand at it.

People made cassette copies of his parties and passed them along to friends. Other DJs started imitating him. Another Bronx teen, Joe Saddler (originally from Barbados), thought he could improve on Herc's technique.

It was in the community room of this apartment building at 1520 Sedgwick Avenue in the Bronx that Kool Herc gave hip-hop its start. It wasn't long before local dancers started showing off their moves during the seamlessly woven instrumental breaks he created: break dancers.

He started transitioning from the break in one song to the break in the next song, and spinning a record back and forth, what became known as "scratching." Others pioneered their own techniques.

Born in the Bronx, influenced by the rhythms of the Caribbean, a new form of music was here to stay.

Joe Saddler became known as Grandmaster Flash and founded the Furious Five, hip-hop's first supergroup.

Another early hip-hop pioneer from the Bronx was Afrika Bambaataa, who is credited with giving hip-hop its name. The phrase was often used by MCs in their rhyming, and he had the idea to apply it to the new form of music and dance that was emerging.

e francs de dégâts ?

.e feu a été d... Montreux. Il s'est dé-
...ré vers ... grande salle, alors que
...0 personnes applaudissaient un concert de pop-
...sique. En quelques minutes, un brasier géant. En
...lques heures, un bâtiment presque entièrement
...anti. Il ne reste que les murs et deux ou trois
...its locaux
...'origine du sinistre est inconnu. Il a par...
...rt-circuit, d'un spot éclaté... d'...

SMOKE GETS IN YOUR EYES

1971

Flames of

inspiration

On September 4, 1971, Frank Zappa and the Mothers of Invention were performing before a crowd of three thousand in Montreux, Switzerland. The concert was taking place at an old casino overlooking Lake Geneva.

The band was just wrapping up the encore when an overenthusiastic member of the audience fired a flare gun into the ceiling and fire broke out. It didn't seem serious at first, but soon flaming sections of the balcony crashed down on the seats below, and the crowd rushed for the exit. The disastrous fire burned the casino to the ground. Zappa and his band lost all of their equipment. Miraculously, the audience all got out safely with only a few injuries.

Across Lake Geneva, the members of another band watched the disaster unfold with anguish in their eyes. Deep Purple was supposed to start recording an album at the casino the next day. Their plans went up in smoke . . . but out of the ashes came a huge hit.

The sight of the blazing inferno seared itself into their brains, inspiring a song with a thundering opening guitar riff that would eventually burn the vivid image into the brains of millions of fans.

Smoke on the water . . . fire in the sky.

The title phrase "Smoke on the Water" came to bassist Roger Glover a few days later when he awoke from a dream about the fire.

The "funky Claude" mentioned in the song is Claude Nobs, the founder of the Montreux Jazz Festival, who helped save several audience members from the flames.

Deep Purple was planning to record at the casino using a mobile studio built by the Rolling Stones. They eventually recorded most of the album at an abandoned hotel nearby. The Rolling Stones' van was also used over the years by Fleetwood Mac, Led Zeppelin, Bob Marley, Patti Smith, and dozens of others.

EMPTY ORCHESTRA

Sing, sing, sing

Daisuke Inoue was the drummer and business manager for a bar band in Kobe, Japan. "Of 108 club musicians in Kobe, I was the worst," he later said. The band eked out a living playing instrumental versions of popular Japanese songs while middle-aged businessmen grabbed the microphone and belted out the lyrics.

One customer, the president of a steel plant, asked Inoue if he could bring the band on a business trip and play backup for him there. Instead, Inoue made a tape for him. The businessman happily paid for it and later reported his performance was a big success.

That gave Inoue an idea.

He and his band constructed eleven homemade boxes with tapes of their instrumental music and leased them to bars in the 1970s. It started a trend that eventually spread around the globe and is still going strong today.

The Japanese called it by a term that translates as "Empty Orchestra" and refers to a recording with no vocal track.

Karaoke.

Inoue never patented his idea. "I took a car stereo, a coin box, and a small amp to make the karaoke. Who would even consider patenting something like that?" That decision likely cost him hundreds of millions of dollars.

Filipino inventor Roberto del Rosario patented the Karaoke Sing Along System in 1975. Karaoke was and remains hugely popular in the Philippines, where karaoke machines can be found at bars, family gatherings, even rural street corners. One song not on many of those machines is "My Way," written by Paul Anka for Frank Sinatra. At least half a dozen people in the Philippines have been killed in arguments that broke out after the singing of "My Way"—leading to the song's deletion.

LAST CALL

Drinking in some great music

Arlo Guthrie was packing up his guitars after performing at the Quiet Knight folk club in Chicago when a young man came up and asked if he could play Guthrie a composition he had just written. *Oh no,* thought Guthrie. It was two in the morning, he was beat, and the last thing he wanted to do was hear some eager would-be songwriter play some god-awful song and then look at him expectantly for praise. Still, he didn't want to be rude.

"I'll tell you what," Guthrie later recalled saying. "You buy me a beer, and I'll sit here and I'll drink it. And as long as it lasts, well, you can do anything you want."

As Guthrie sipped his beer, Steve Goodman began to play a song that would become the biggest hit of Guthrie's career. A song that later became a Grammy-winning number-one country hit for Willie Nelson. A song Johnny Cash has called "the best damn train song ever written." A haunting melody called "The City of New Orleans" about the train from Chicago to New Orleans that bears that name. A song with the familiar refrain "Good morning, America, how are you?" that has made it an American standard.

Said Guthrie later: "Turned out to be one of the finer beers in my life."

Goodman wrote the song on the Illinois Central train one Monday morning while he and his wife, Nancy, were on their way to visit her ninety-three-year-old grandmother in southern Illinois. Goodman later told a reporter, "Everything in the song really happened."

> ## "GOOD MORNING, AMERICA, HOW ARE YOU?
> ## DON'T YOU KNOW ME, I'M YOUR NATIVE SON.
> ## I'M THE TRAIN THEY CALL THE CITY OF NEW
> ## ORLEANS, I'LL BE GONE FIVE HUNDRED MILES
> ## WHEN THE DAY IS DONE."

Goodman was a talented and prolific songwriter whose career was tragically cut short by leukemia at age thirty-six. Three years before he died he wrote a song that has become a baseball classic: "The Dying Cub Fan's Last Request." It is a humorous lament for the perennially hapless Chicago Cubs.

You know the law of averages says:

"Anything will happen that can"
But the last time the Cubs won a National
League pennant
Was the year we dropped the bomb on
Japan*

After his death, Goodman's ashes were scattered at Wrigley Field.

*Still true as of this writing.

THE LONG AND WINDING ROAD

How many singers does it take to make a hit song?

It began with a concert by Don McLean at the Troubadour in Los Angeles. One of the people in the audience was twenty-year-old Lori Lieberman, who was trying to make it as a folksinger. She knew hardly anything about McLean's work, except for his megahit "American Pie." But she found herself spellbound. Sitting in the darkened audience, Lieberman was overwhelmed by the feeling that McLean was looking right into her soul and telling the story of her life.

Lieberman described her experience to the songwriting team of Norman Gimbel and Charles Fox, who were producing her debut record album. They wrote a song that captured her powerful feelings, and it wound up on the record.

Although it didn't exactly set the world on fire, the song did get picked up by American Airlines for one of its in-flight music programs. At three o'clock in the morning, on a red-eye flight from Los Angeles to New York, singer Roberta Flack was leafing through an in-flight magazine when she saw a blurb on the song and tuned in to hear it.

It wasn't "American Pie" that most inspired Lieberman, it was a lesser-known album track called "Empty Chairs." "I was going through some difficult things at the time," said Lieberman, "and what he was singing about made me think, 'Whoa! This person knows me! How could he know me so well?'"

"By the time I got to New York I knew I had to do that song."

"Killing Me Softly with His Song" went on to win the 1974 Grammys for Record of the Year and Song of the Year. *Billboard* magazine has ranked it as one of the top 100 pop songs of all time. Says Don McLean, the man who started it all: "I must say I'm very humbled about the whole thing."

Gimbel and Fox went on to write many successful TV theme songs, including the one for the long-running show Happy Days. Lieberman later had a falling-out with the songwriting duo that led to lawsuits and a dispute over her role in the creation of "Killing Me Softly with His Song."

Lightning struck twice for the song when it became a huge hit for Lauryn Hill and the Fugees in 1996.

THE TRUTH WILL SET YOU FREE

*The musical inspired
by Watergate*

I n the summer of 1973, millions of Americans were riveted to their television sets, watching the Watergate hearings unfold. Weeks of testimony revealed the cover-up being conducted by the White House, and ultimately resulted in the resignation of President Richard Nixon.

In Bridgehampton, New York, one of the people watching the hearings found himself disgusted by all the lying and deception, and yearning for something different. "God, truth!" exclaimed Michael Bennett to himself. "Would I like to see some truth in life!"

Bennett sought truth by getting together with a group of friends and friends of friends, a homegrown group-therapy session that started at midnight one night and lasted until dawn. All of them were Broadway dancers, and they poured out the unvarnished truth about their lives, their insecurities, passions, and fears.

The truth proved to be pretty popular.

The Watergate hearings made a star of Senator Sam Ervin, chairman of the committee. It also proved a launching pad for the political and acting careers of a young lawyer named Fred Thompson, who went on to be a senator from Tennessee and a star of Law & Order.

A reel-to-reel tape recorder was rolling that night, and the stories it recorded became the basis for one of the most successful Broadway musicals of all time, a smash hit inspired by Watergate that made the usually anonymous dancers the stars of the show.

A Chorus Line.

A Chorus Line won nine Tonys and a Pulitzer Prize for Drama. While the late Michael Bennett is credited as the creator of the show, he didn't do it alone. Nick Dante and James Kirkwood wrote the book; Marvin Hamlisch and Ed Kleban wrote the songs.

With its 3,389th performance, A Chorus Line became the longest-running musical in Broadway history up to that time. Bennett invited everyone who had ever played in the show to take part in that performance. Three hundred thirty-two dancers crowded a specially reinforced stage to put on one of the most extraordinary performances of the show ever staged. Preparations for that one night took three months and cost half a million dollars.

PREACHING TO THE CHOIR

*Heavenly inspiration
that really stuck*

A rt Fry was a singer in the choir at the North Presbyterian Church in St. Paul, Minnesota. Every Sunday he would mark the songs in his hymnal with slips of paper so he could easily find them. Sometimes the slips would fall out, and Fry would have to madly flip through the pages to get to the next hymn in time.

After it happened one time too many, he sat there in church wondering if there was an answer. "I don't know if it was a dull sermon or divine inspiration," says Fry, "but my mind began to wander."

Fry worked at 3M, and his mind wandered to a glue invented by one of his co-workers, a chemist named Spencer Silver. The glue was peculiar stuff: it wasn't particularly sticky, and it wouldn't dry. By coating the paper slips with Silver's stuff, Fry figured he could make a bookmark that wouldn't fall out.

So was born the Post-it Note.

The product was a big hit at 3M headquarters, but it failed miserably when test-marketed. Nobody wanted to pay a dollar for a pad of sticky notepaper they couldn't figure out how to use. So 3M hit on the idea of giving the pads away and hoping people would get hooked.

It worked—and Post-it Notes have stuck with us ever since.

Fry remembered Silver and his not-too-sticky adhesive because for years Silver would visit anyone at the 3M headquarters in St. Paul, Minnesota, who would listen and show them the stuff, encouraging them to think of a use for it.

Two determined 3M executives saved Post-it Notes from the trash heap. They flew to Richmond, Virginia, site of the failed market test, and walked door to door on the main street of the business district, giving pads of Post-it Notes to anyone who would take them. They made addicts wherever they went. They followed up with what became known as the "Boise Blitz," a massive distribution of free samples in Boise, Idaho. The marketing of Post-it Notes was so successful that today it is studied by would-be entrepreneurs around the world.







**1976**

NEW YORK STATE OF MIND

An actor's displeasure inspires a legendary anthem

Songwriters John Kander and Fred Ebb sat down at the piano to bang out the songs that they had written for director Martin Scorsese's new movie. Scorsese and actress Liza Minnelli, the film's leading lady, liked the music just fine. But over on the couch, storm clouds were gathering on the face of actor Robert De Niro. He thought the title song that the writers had composed for the movie was pretty weak, and he wasn't shy about saying so. He had a question. Could they try again?

Ebb and Kander had written the hit musical *Cabaret* just a few years before, and they took great umbrage at the request. "We walked out of there," Kander recalled, "highly insulted that *some actor* was going to tell us how to write a song."

Nevertheless, they agreed to make a brand-new start of it. Still smoldering, they dashed off a new song in about an hour. Their anger lent the song an air of defiance. Said Kander: "Our attitude was, 'We'll show that actor!'"

Actually, he showed them the way to the biggest hit of their career.

The movie *New York, New York* was a big-budget flop, forgotten today by all but a few hard-core film buffs. But the title song, born out of annoyance with Robert De Niro, would go

At the time they were making New York, New York, *De Niro and Scorsese had just scored a big hit with* Taxi Driver. *But neither was yet the megastar each became.*









on to become a monster hit for Frank Sinatra, a staple of karaoke bars, and the unofficial anthem of the Big Apple.

And if you can make it there, you can make it anywhere . . .

Kander later said the new song was a hundred times better than the original.

THE LULLABY OF BROADWAY

Triumph and tragedy on opening night

The musical *42nd Street* tells the story of "the biggest Broadway show in twenty years" being put on in spite of disasters left and right. It trades unabashedly on every show business cliché in the book. When the prima-donna lead actress breaks her ankle, the plucky unknown from Allentown is given the job.

After all, the show must go on.

The backstage story was equally interesting. Director and choreographer Gower Champion had stumbled after directing such monster hits as *Hello, Dolly!* and *Bye Bye Birdie*. By 1980, some people considered him a has-been. This splashy big-budget musical was his chance to make a sensational comeback.

He threw himself into it. One dancer recalled him leaping all over the stage to demonstrate what he wanted. This in spite of the fact that he was apparently suffering from a nasty bug that occasionally forced him to miss rehearsal.

Producer David Merrick came out after the tenth curtain call to announce Gower's death. The cast standing behind him was just as stunned as the audience in front. Then actor Jerry Orbach (right) had the presence of mind to call out, "Bring it down!" The curtain fell as cast members began to weep.

Opening night was a triumph. The dancing feet of *42nd Street* were a huge hit. The cast made ten curtain calls for the cheering audience. But one person wasn't there to savor the moment. Neither cast nor audience were told until after the show that Gower Champion had died that very afternoon of a rare cancer of the blood.

After all, the show must go on.

Gower Champion began dancing at age fifteen. He and his wife, Marge, won fame as a dance couple in the 1940s and won national acclaim when they started appearing on Sid Caesar's TV show in the 1950s.

4 *2nd Street* went on to win Tony Awards for Best Musical and Best Choreography.

WHAT CAN BROWN DO FOR YOU?

Lessons from Van Halen's dressing room

When rock stars go on tour, they are famous for making extreme demands simply because they can. One of the most excessive examples comes from the 1980s world tour by Van Halen, with lead singer David Lee Roth. Halfway down page 40 of the fifty-three-page contract, it specified that the band's dressing rooms must be supplied with M&Ms, but that there must be "ABSOLUTELY NO BROWN ONES!"

So if Van Halen was coming to town, some flunky had to carefully remove all the brown ones from the M&M bowl. Or worse, the venue would feel the wrath of Roth if they didn't. He supposedly caused thousands of dollars of damage at one concert venue upon being served brown M&Ms.

A ridiculous example of superstar arrogance, right?

Not exactly. The Van Halen tour was huge for its day, ten trailer trucks of equipment, with myriad technical needs that filled dozens of pages in the contract. The brown M&Ms clause served as a canary in the coal mine, an easy way to see if the promoter was really prepared for the band. "If I saw a brown M&M in that bowl," said Roth, "they didn't read the contract. Guaranteed you'd run into a problem."

```
Munchies

    Potato chips with assorted dips
    Nuts
    Pretzels
    M & M's (WARNING: NO BROWN ONES)
    Twelve (12) Reese's peanut butter cups
    Twelve (12) assorted Dannon yogurt (on ice)
```

Today, instead of being considered a sign of rock star ego gone mad, the brown M&M test is not only emulated by other musicians, but also cited by business consultants around the world. A lesson learned at the school of rock.

Roth did trash a dressing room in Pueblo, Colorado, once when served brown M&Ms. Press reports said his tantrum caused $85,000 worth of damage. But what they left out was that almost all of that damage actually resulted from the promoter failing to comprehend the weight of the stage, which destroyed the arena's new basketball floor. Says Roth: "Who am I to get in the way of a good rumor?"

Roth hooked up with the band in 1973 when brothers Eddie and Alex Van Halen rented his PA system, then decided it would be cheaper to bring Roth on as lead singer—as long as he threw in the PA for free.

Van Halen's contract rider also called for the band to be supplied with a tube of K-Y Jelly and forty-eight bath towels. It has never been argued that these serve any business purpose.

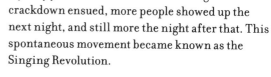

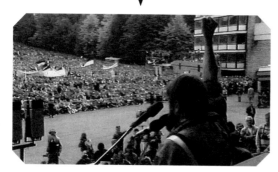

THE SINGING REVOLUTION

*A peaceful uprising
powered by music*

It is hard to imagine people literally singing their way to freedom. But something very much like that happened in the small Baltic country of Estonia.

Choral music is an integral part of Estonian culture and goes hand in hand with a fervent love of country. Since 1869 a huge choral song festival has been held every five years.

During World War II, the Soviet Union invaded Estonia, and the Communists ruled it for decades with a harsh hand. By 1988, things were changing. Soviet leader Mikhail Gorbachev had introduced a loosening of control under the banner of *perestroika* and *glasnost*. Still, Estonia and much of the rest of Eastern Europe remained under Soviet domination.

In June of that year, protesters gathered one night on the grounds of the Tallinn Song Festival. They sang patriotic songs and waved flags that had remained hidden for nearly fifty years of Soviet rule. When no government crackdown ensued, more people showed up the next night, and still more the night after that. This spontaneous movement became known as the Singing Revolution.

On September 11, 1988, a protest event called "The Song of Estonia" was held at the same location. More than 300,000 people showed up, one-quarter of the entire country. Speakers demanded action, and the size of the crowd emboldened legislative

leaders to start pushing for change. A fire was lit that burned until independence was finally restored in 1991.

Something to sing about.

On August 23, 1989, 2 million people from Estonia, Latvia, and Lithuania joined hands along 350 miles of road across the three Baltic countries to underscore their demand for independence from the Soviet Union. The Berlin Wall came down three months later.

> **UNTIL NOW, REVOLUTIONS HAVE BEEN FILLED WITH DESTRUCTION, BURNING, KILLING, AND HATE. WE STARTED OUR REVOLUTION WITH A SMILE AND A SONG.**
>
> —ESTONIAN ACTIVIST AND ARTIST HEINZ VALK

THE AMAZING BONE

Back to the beginning

An archaeologist finds a bone—not a particularly unusual event. But this particular bone, discovered in a prehistoric hunting camp in Slovenia, turned out to be something special. The hollowed-out bone had two holes in the middle, and evidence of two more where it was broken. The alignment suggested it was probably an ancient flute.

How ancient? The bone has been dated as being more than fifty thousand years old. That would make it the oldest musical instrument ever discovered. What's more, the campsite in which it was discovered didn't belong to modern humans—*Homo sapiens*—but to a group of Neanderthals, an extinct species of humans that died out about 30,000 years ago.

There is some controversy over whether the bone really is a flute, but if it is, it suggests that music is older than we are. Think about that for a minute—that modern man might not have created music, but was born into a world where music already existed.

And since many scientists believe the Neanderthals had no spoken language, it may be proof that music is the first form of communication, predating words.

And if music was Neanderthal man's gift to us, it may be that songs handed down for generations may be much older than we know, that tunes still familiar today may be some of the oldest ideas in the world, and a link to cave dwellers of a distant past.

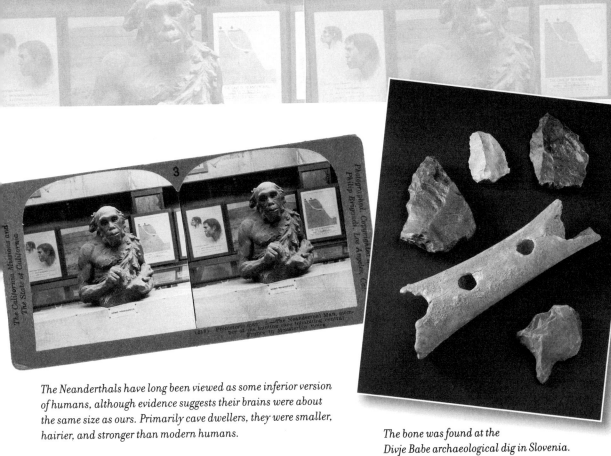

3

HOMO PRIMIGENIUS

HOMO PRIMIGENIUS

(4299) Prehistoric man.—The Neanderthal Man, member of the hunting race inhabiting central France in Mousterian times.

The Neanderthals have long been viewed as some inferior version of humans, although evidence suggests their brains were about the same size as ours. Primarily cave dwellers, they were smaller, hairier, and stronger than modern humans.

The bone was found at the Divje Babe archaeological dig in Slovenia. It is now at the National Museum of Slovenia. At least one musicologist believes the bone-flute was tuned to a diatonic scale, suggesting it would have made melodies remarkably similar to those we are familiar with today.

LOST AND FOUND

Amazing grace

In 1944, Leon Fleisher burst on the classical music scene as a sixteen-year-old virtuoso pianist. He was hailed as one of the greatest pianists of the century. Then, in 1964, at the height of his powers, disaster struck.

Fleisher was preparing for a tour of the Soviet Union when the fingers of his right hand began to curl up. He responded by practicing harder. Within ten months his fingers were clenched in a fist, and he could no longer play piano with his right hand.

Fleisher saw dozens of doctors and tried everything from aromatherapy to Zen Buddhism, but to no avail. "Since the age of four, this was it for me. And suddenly I couldn't do it. . . . I was desolate." His marriage fell apart. He felt like giving up.

But he didn't.

Instead, he threw himself into teaching. He learned to conduct. He began performing the small number of classical pieces that can be played only with the left hand. And he kept believing that someday a miracle would happen.

Doctors eventually diagnosed his problem as focal dystonia, a rare neurological disorder. In the mid-1990s, experimental Botox treatments restored the use of his right hand. In 2003,

At the 2007 Kennedy Center Honors, Fleisher was recognized as "a consummate musician whose career is a testament to the life-affirming power of art."

he staged a triumphant return to Carnegie Hall to play his first two-handed concert there in more than four decades.

Fleisher as a sixteen-year-old wunderkind.

Did his thirty years in the wilderness simply rob him of playing time or confer upon him a grace and depth he otherwise wouldn't have achieved? Fleisher himself doesn't know, but says, "I'm not sure I would change anything that happened to me."

After Austrian pianist Paul Wittgenstein lost his arm in World War I, he commissioned several composers, including Ravel, Prokofiev, and Benjamin Britten (seated on Wittgenstein's left), to create pieces designed to be played only with the left hand.

Fleisher says his condition made him a better teacher, because he was no longer able to push the student aside and show them how to do it. He had to develop his ability to explain without demonstrating.

> **"WE SPEND A GREAT PORTION OF OUR LIVES EITHER TRYING TO RECAPTURE THINGS OR SETTING UP THINGS TO ACHIEVE. AND IN DOING, WE OFTEN FAIL TO LIVE THE NOW."**

—LEON FLEISHER

COME TUMBLIN' DOWN

Military music of a different sort

Music hath charms to soothe a savage breast," wrote William Congreve. But music itself can occasionally be used for a savage purpose: as a weapon of war. The Bible says Joshua's trumpeters, blowing on their ram's horns, caused the walls of Jericho to come tumbling down, allowing Joshua's army to raze the fortified city. But there are far more recent examples.

In 1990, Panamanian dictator Manuel Noriega holed up in the Vatican embassy when U.S. soldiers invaded his country. The Americans blasted the compound day and night with loud music, including songs from the hard-rock band AC/DC, in an attempt to hasten his surrender. It gave new meaning to their song "You Shook Me All Night Long."

In 1993, agents from the Bureau of Alcohol, Tobacco and Firearms besieging the Branch Davidian compound in Waco, Texas, blasted a much greater variety of music to disorient leader David Koresh and his followers. Selections included Tibetan chants, Christmas music, "Reveille," and, strangely, "These Boots Are Made for Walkin' " by Nancy Sinatra. A government spokesman, presumably with tongue in cheek, said they had considered and rejected the idea of playing "Achy Breaky Heart" by Billy Ray Cyrus.

And in 2005, the Israeli army began using a new non-lethal weapon called "The Scream." Taking a cue, perhaps, from what is known as "scream rock," this

THE WALLS OF JERICHO FALL DOWN. "SO THE PEOPLE SHOUTED WHEN THE PRIESTS BLEW WITH THE TRUMPET
...ND IT CAME TO PASS, WHEN THE PEOPLE HEARD THE SOUND OF THE TRUMPET, AND THE PEOPLE SHOUTE
...TH A GREAT SHOUT, THAT THE WALL FELL DOWN FLAT . . ." JOSHUA VI, 20, FROM AN ORIGINAL WOODCUT
PUBLISHED IN 1860 BY GEORGE WIGAND, LEIPZIG

device emits a burst of high-frequency sound that can create dizziness and nausea. (Classical fans who have accompanied their children to heavy metal concerts will understand.) One expert described it as "firing bullets of sound."

Something Joshua himself would have appreciated.

ATF agents in Waco. This was one case where using music as a weapon seriously backfired. Negotiations broke down, leading to a government assault on the compound that killed eighty-six people.

Panamanian dictator Manuel Noriega in 1987. As of January 2011, he is behind bars in France, serving out a seven-year prison term for money laundering.

ROCKING THE COSMOS

Of stars and guitars

Dr. Brian May is an astrophysicist. He studied math and physics at Imperial College in London and eventually earned his doctorate there. His PhD thesis on dust in the solar system was titled *A Survey of Radial Velocities in the Zodiacal Dust Cloud*. He went on to write a book about the history of the universe and become chancellor of John Moore's University in Liverpool.

That's a quick view of Dr. May's resume. But it does leave one thing out. Although he began studying for his degree in the early 1970s, he didn't manage to earn it until 2007. Something came up, you might say, and sidetracked him for thirty-five years.

The man who loved studying stars became one.

When he wasn't studying astrophysics, Brian played guitar. And his band was getting so busy that he had to make a choice between school and his music. The band was called Smile, until lead singer Farrokh Bulsara suggested a different name.

Queen.

Bulsara changed his name to Freddie Mercury, Brian May left his studies behind to go on tour, and Queen went on to become one of the biggest music

May says his physics training helped him with his music career. It came in handy, for instance, when he was designing the "stomp, stomp, clap" section of "We Will Rock You." In an age before digital, he was able to make the calculations necessary to create the sound of thousands of people stomping and clapping with no echo whatsoever.

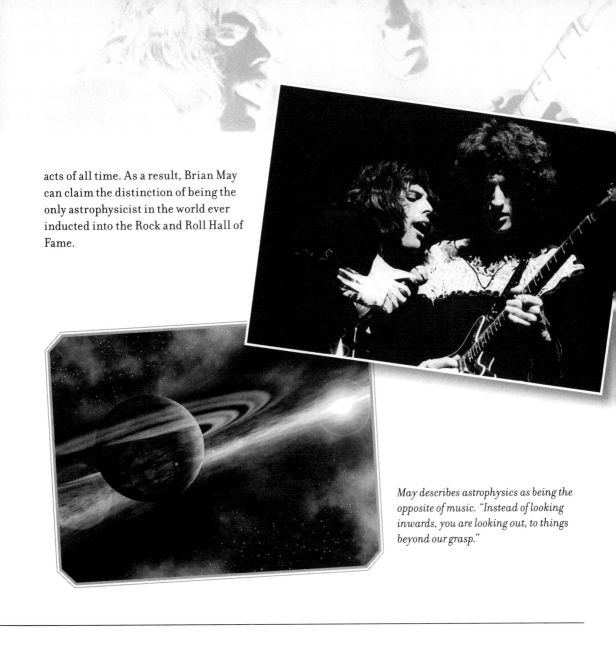

acts of all time. As a result, Brian May can claim the distinction of being the only astrophysicist in the world ever inducted into the Rock and Roll Hall of Fame.

May describes astrophysics as being the opposite of music. "Instead of looking inwards, you are looking out, to things beyond our grasp."

I nformation is only as good as its source. Although this is not meant to be a scholarly work, readers still deserve to know the principal sources for each story, so that they can judge for themselves how accurate it is, and where to go to find out more. It also is appropriate to give credit to the many authors and publications whose work I have relied on. I've provided a story-by-story list with the selected sources for each.

Not every source I drew from is listed here. In some cases I consulted a dozen or more articles, books, and websites in search of stray facts, verification of what I had already discovered, or any hint that the story in question might not be true. Some I went to time after time. *Encyclopedia Britannica* (www.britannica.com) is a wonderful source for basic historical information. The *New York Times* archive, available through many libraries, allows word searching of stories going back to 1857. The *Time* magazine archive (www.time.com) allows word searching of articles back to 1923.

There are an increasing number of websites containing primary-source material or scholarly research. JSTOR and PROJECT MUSE each contain articles from hundreds of scholarly journals and were indispensable in the writing of this book. For anyone interested in early recorded music, the Cylinder Preservation and Digitization Project is a fantastic resource. And Google Books is invaluable for putting your hands on obscure texts that otherwise might take weeks to track down.

But even in the age of the Internet, research still requires hours with your nose in a book. I became intimately familiar with the 780 section (Dewey decimal system) of the Cary Memorial Library in

Lexington, and some of my favorite stories were found by perusing books discovered by accident on the shelf. I hope that joy of serendipitous discovery in the stacks of a library is one that will be available to future generations.

The Mother of All Golden Oldies: *Ancient Inventions* by Nick Thorpe and Peter James; "A Forgotten Melody," *Time*, March 18, 1974.

Divine Harmony: *Measure for Measure* by Thomas Levenson; *Early Greek Philosophy* by Jonathan Barnes; "The Dangerous Ratio or to Be Male Is Odd" by Brian Clegg, *NRICH Project*, http://nrich. maths.org/2671.

Fire in the Sky: "The Burning of Rome, 64 AD," *EyeWitness to History*, http://www.eyewitnesstohistory. com; "Dio Cassius: Nero and the Great Fire 64 CE," *Ancient History Sourcebook*, http://www.fordham.edu/ halsall/ancient/diocassius-nero1.html.

The d'Arezzo Code: "Guido d'Arezzo: Medieval Musician and Educator" by Samuel D. Miller, *Journal of Research in Music Education*, vol. 21, no. 3 (Autumn 1973), accessed at http://www.jstor.org/ stable/3345093; *Catholic Encyclopedia*.

The Beat Goes On: "Lully, Jean-Baptiste," *The Grove Concise Dictionary of Music* edited by Stanley Sadie; "Lully, Jean-Baptiste," *New World Encyclopedia*.

Roots Music: *Sinful Tunes and Spirituals: Black Folk Music to the Civil War* by Dena J. Epstein; *Music in Eighteenth-Century Georgia* by Ronald L. Byrnside; *The Banjo Project*, a film and website by Marc Fields.

Gods of Guitar: *Life and Times of Benjamin Franklin, Volume 1* by James Parton; *Franz Schubert: Complete Chamber Music with Guitar* by Stephen Mattingly; " 'This Easy and Agreeable Instrument': A History of the English Guittar" by Philip Coggin, *Early Music*, vol. 15, no. 2, Plucked String Issue (May 1987), accessed at http://www.jstor.org/stable/3127482.

But for a Button: *Handel* by R. A. Streatfield; *Stories Behind the World's Great Music* by Sigmund Spaeth; *Handel's Messiah: Comfort for God's People* by Calvin R. Stapert; "Handel's Messiah: Some Notes on Its History and First Performance" by F. G. Edwards, *The Musical Times*, November 1, 1902.

Give the Devil His Due: *The Great Violinists and Pianists* by George Titus Ferris; *Classical Music: The Listener's Companion* edited by Alexander J. Morin; *The Sabbath Recorder*, Volume 80, by American Sabbath Tract Society.

Onstage at the Coffeehouse: *Bach* by Malcolm Boyd; *All About Coffee* by William Ukers.

Shear Madness: "Hit the High Notes" by Laura Stuart, *University of Chicago Magazine*, vol. 99, issue 6 (July–August 2007); *Secret Lives of Great Composers* by Elizabeth Lunday.

Salvation Serenade: *The Atlantic Slave Trade* by David Northrup; *Amazing Grace: John Newton's Story* by John Charles Pollock; information provided by the Cowper-Newton Museum in the United Kingdom, http://www.cowperandnewtonmuseum.org.

A Dandy Tale: *America's Song: The Story of Yankee Doodle* by Stuart Murray; "Yankee Doodle," Library of Congress website, http://lcweb2.loc.gov/ammem/today/apr19.html.

Musical Mystery Tour: *Benjamin Franklin, An American Life* by Walter Isaacson; "The Glass Harmonica: A Return from Obscurity" by Gerhard Finkenbeiner and Vera Meyer, *Leonardo*, vol. 20, no. 2; "History of the Glass Harmonica" by Elijah Wald, http://www.elijahwald.com/glasshar.html.

Playing It by Ear: *Mozart* by Maynard Solomon; "Allegri's 'Miserere,'" *Musical Times*, August 1, 1885.

National Treasure: *Popular American Composers* by David Ewen; "William Billings and His Times" by Carl E. Lindstrom, *The Musical Quarterly*, vol. 25, no. 4 (October 1939), accessed at http://www.jstor.org/pss/738861.

The Queen and the Ditty: *Love Me Tender* by Max Cryer; "The Eighteenth-Century Vogue of 'Malbrough' and Marlborough" by C. D. Brenner, *The Modern Language Review*, vol. 45, no. 2 (April 1950), accessed at http://www.jstor.org/pss/3719433.

Those Were the Days: *Love Me Tender* by Max Cryer; "Gay Days at Lakewood," *New York Times*, January 5, 1896; *Burns Country*, http://www.robertburns.org.

I Will Survive: *Steinway* by Ronald V. Ratcliffe and Stuart Isacoff; *The PianoForte* by William Leslie Summer.

"The Star-Spangled Banner": Various documents and clippings from the National Museum of American History.

An American Army of Two: "Along the South Shore" by S. G. W. Benjamin, *Harper's Monthly*, vol. 57, issue 337 (1878); *To the Point: The Story of Cedar Point Light* by David Ball; interview with David Ball, President, Scituate Historical Society, December 9, 2004, along with various documents supplied by the society.

Measure for Measure: *Beethoven Symphony No. 9* by Nicholas Cook; *Lexicon of Musical Invective* by Nicolas Slonimsky.

Something About Mary: *Henry Ford and Grass-roots America* by Reynold M. Wik; "The True Story of Mary's Little Lamb," *Dearborn Independent Magazine*, January 1927–May 1927.

Science in the Key of C: *Sounds of Our Times* by Robert T. Beyer; *Archimedes to Hawking* by Clifford A. Pickover.

Twist and Shout: *Franz Liszt, The Virtuoso Years* by Alan Walker; *The Virtuoso Liszt* by Dana Andrew Gooley.

Hail to the Wives!: "Hail to the Chief," *Patriotic Melodies*, http://lcweb2.loc.gov/cocoon/ihas/loc. natlib.ihas.200000009/default.html; *US Marine Band*, http://www.marineband.usmc.

Strauss vs. Strauss: *The Waltz Kings* by Hans Fantel; *The Waltz Emperors* by Joseph Wechberg.

Saved by a Song: *A Treasury of White House Tales* by Web Garrison; "Fatal Cruise of the Princeton" by Ann Blackman, *Naval History*, September 2005.

Battle of the Bands: *Grove Dictionary of Music*; "Adolphe Sax and His Saxophone" by Leon Kochnitzky, http://www.saxgourmet.com; "Adolphe Sax, A Dinantais of Genius" compiled by Albert Rémy, *Official City of Dinant Web Site*, http://www.dinant.be/index.htm?lg=3&m1=28&m2=88&m3=293.

Whatever Lola Wants: *Lola Montez, A Life* by Bruce Seymour; *Secret Lives of the Composers* by Elizabeth Lunday; various articles in the *New York Times*.

Battle of the Bells: "Origin of 'Jingle Bells' Song Is Debated" by Russ Bynum, *Associated Press*, Sunday, December 21, 2003; "Christmas Cards" by Owen Edwards, *Smithsonian*, December 2005.

Daring Young Man: *Circus Bodies* by Peta Tait; *Victorian Sensation* by Michael Diamond; "The Variety State," *Chambers Journal of Popular Literature, Science, and Art*, vol. 68, March 14, 1891.

Not Whistling Dixie: *American Popular Songs* by David Ewen; *The Civil War* by Shelby Foote; *Dan Emmett and the Rise of the Early Negro Minstrelsy* by Hans Nathan; "Daniel Decatur Emmett's Dixie" by George Bird Evans.

One-Hit Wonder: "Oldest Recorded Voices Sing Again," *BBC News Online*, March 28, 2008, http://news.bbc.co.uk/2/hi/7318180.stm; "Researchers Play Tune Recorded Before Edison," *New York Times*, March 27, 2008.

The Other John Brown: "Origin of the John Brown Song" by George Kimball, *The New England Magazine*, vol. 7, issue 4 (December 1889); *Songs of the Civil War* by Irwin Silber and Jerry Silverman.

From Drummer Boy to Major General: "Milestones," *Time*, May 24, 1937; "Last Veteran of 61 to Leave the Army," *New York Times*, August 6, 1915.

Twenty-four Notes: *Army Letters 1861–1865* by O. W. Norton; *The Army of the Potomac: Mr. Lincoln's Army* by Bruce Catton; "24 Notes That Tap Deep Emotions" by Jari A. Villaneueva, www.west-point.org/taps/Taps.html.

Watching the Clock: *Popular American Composers* by David Ewen; "The Mysterious Chord of Henry Clay Work" by Richard S. Hill, *Notes*, Second Series, vol. 10, no. 2 (March 1953), accessed at http://www.jstor.org/stable/892874.

The Patroness: *Beloved Friend* by Catherine Drinker Bowen; *Secret Lives of the Composers* by Elizabeth Lunday.

The Song Ship: "Prolegomena to a History of the Ukulele" by John King, *Ukulele Guild of Hawaii*, http://www.ukuleleguild.org/history.php; "Machetes and Rajoes and Taropatches, Oh, My! The Ukulele and Its Predecessors in Late-Nineteenth-Century Hawaiian Music" by John King, *Ukelele Yes!*, http://www.ukuleleyes.com/issues/vol7/no3/feature.htm.

Wanna Make a Record?: *Lost Sounds* by Tim Brooks; various articles in the *New York Times*.

The First Music Video: *Kohn on Music Licensing* by Al and Bob Kohn; *The Story of the House of Witmark* by Isadore Witmark; "The First Music Video," *Timelab 2000*, a series of history minutes produced by Rick Beyer.

Good Morning to All: "Copyright and the World's Most Popular Song" by Robert Brauneis, George Washington University–Law School, GWU Legal Studies Research Paper No. 1111624, October 14, 2010, accessed at http://papers.ssrn.com/sol3/papers.cfm?abstract_id=1111624; *The Book of World-Famous Music: Classical, Popular, and Folk* by James J. Fuld.

Chartbuster: *Record Label Marketing* by Thomas William Hutchison, Amy Macy, and Paul Allen; "Billboard History" by Ken Schlager, *Billboard Magazine*, accessed at http://web.archive.org/web/20051213024449/http://www.billboard.com/bbcom/about_us/bbhistory.jsp.

Take a Bow (Wow): *The Story of 'Nipper' and the 'His Master's Voice' Picture Painted by Francis Barraud* by Leonard Petts.

Ridiculous to Sublime: *Wallace Clement Sabine* by William Dana Ocutt; *Sounds of Our Times* by Robert T. Beyer; *Symphony Hall, The First 100 Years* by Boston Symphony Orchestra/Sametz Blackstone Associates.

The Menace of Mechanical Music: "The Menace of Mechanical Music" by John Philip Sousa, *Appleton's Magazine*, vol. 8 (1906), accessed at http://explorepahistory.com/odocument.php?docId=418; *How the Beatles Destroyed Rock 'n' Roll* by Elijah Wald.

First Man of Jazz?: *In Search of Buddy Bolden, First Man of Jazz* by Donald Marquis; *Hear Me Talkin' to Ya: The Story of Jazz As Told by the Men Who Made It* by Nat Shapiro and Nat Hentoff.

Katie's Lament: *Baseball's Greatest Hit: The Story of Take Me Out to the Ball Game* by Andy Strasberg, Bob Thompson, and Tim Wiles; "Take Me Out to the Ball Game," *Performing Arts Encyclopedia*, Library of Congress, http://www.loc.gov/performingarts.

Anybody Out There?: *Hello Everybody* by Tony Rudell; "Wireless Melody Jarred," *New York Times*, January 14, 1910; "Radio Activity: The 100th Anniversary of Public Broadcasting," Smithsonian.com, http://www.smithsonianmag.com/history-archaeology/Radio-Activity-The—100th-Anniversary-of-Public-Broadcasting.html#ixzz14tNBkm4q.

Wired Wireless: "Sends 2 Programs Over Light Wire," *New York Times*, May 4, 1924; Muzak Corporation archives; *Biographical Memoir of George Owen Squier* by Arthur E. Kenelly, National Academy of Sciences Archive; "Nature's Antennas" by Terence Monmany, *Science*, March 1985; "Trapped in a Musical Elevator" by Otto Friedrich, *Time*, December 10, 1984.

Riot of Spring: *Rites of Spring* by Modris Ecksteins; *Stravinsky, the Rite of Spring* by Peter Hill; *Lexicon of Musical Invective* by Nicolas Slonimsky.

Dance Fever: *The Wicked Waltz and Other Scandalous Dances* by Mark Knowles; various articles in the *New York Times*.

You Say You Want a Revolution: *Chicano Folklore* by Rafaela Castro; *Songs That Changed the World* by Wanda Whitman.

Musical Merry-Go-Round: "Soviet and Russian Anthem Author Mikhalkov Dies at 96," *Ria Novosti*, http://en.rian.ru/russia/20090827/155942753.html.

Strike Up the Band: "National Anthem Begins the Affray," *New York Times*, September 11, 1918; *The Cultural Encyclopedia of Baseball* by Jonathan Fraser Light; *The Babe in Redstockings* by Kerry Keene et al.

Sold for a Song: *The Big Bam* by Lee Montville; various articles in the *New York Times*.

I Read the News Today, Oh Boy!: *The Gershwins* by Robert Kimball and Alfred Simon; *Gershwin: His Life and Music* by Charles Schwartz; "Music" by Olin Downes, *New York Times*, February 13, 1924.

I Beg Your Pardon: *The Land Where the Blues Began* by Alan Lomax; *On the Trail of Negro Folk Songs* by Dorothy Scarborough and Lee Gulledge; *Battles for Peace* by Patrick Morris Neff; "Lead Belly," *Time*, May 15, 1939. This story smacked of something that might be the stuff of myth, but it turned out to be surprisingly well substantiated by independent sources.

The Drums of War: *A History of Drum and Bugle Corps, Volume 2*, edited by Steve Vickers; "Jim Chapin, A Different Drummer, Sounds Off" by Procter Lippincott, *New York Times*, April 1, 1979; "Gene Krupa, Revolutionary Drummer, Died" by John S. Wilson, *New York Times*, October 17, 1973.

Look, Ma, No Hands: "Leon Theremin, Musical Inventor, Is Dead at 97," *New York Times,* November 9, 1993; "Paris Musicians Won by New Instrument," *New York Times*, December 8, 1927; *Odyssey of an Eavesdropper* by Martin L. Kaiser III and Robert S. Stokes.

Bristol Bang: *Country Music USA* by Bill Malone; *Jimmie Rodgers* by Nolan Porterfield; "1927 Bristol Sessions," *Birthplace of Country Music*, http://www.birthplaceofcountrymusic.org/node/28.

The Song That Saved Wheaties: *Business Without Boundary: The Story of General Mills* by James Gray; archival material supplied by General Mills.

One-Night Stand: *Stardust Melody: The Life and Music of Hoagy Carmichael* by Richard M. Sudhalter; "Stuart Gorrell, 61, Retired Bank Aide," *New York Times*, August 8, 1963; *The American Songbook: The Singers, the Songwriters, and the Songs* by Ken Bloom; letter from Mark Saxton to Allen Wad, May 7, 1946, from the Hoagy Carmichael Collection, at Indiana University, accessed at http://www.dlib.indiana.edu/collections/hoagy/.

An American Tune: *Brother, Can You Spare a Dime?: The Life of Composer Jay Gorney* by Sondra Gorney; *Harold Arlen: Rhythm, Rainbows, and Blues* by Edward Jablonski; *America in the 1930s* by Edmund Lindop; *Who Put the Rainbow in the Wizard of Oz?: Yip Harburg, Lyricist* by Harold Meyerson and Ernie Harburg.

Hot Lipps Starts a Trend: "George P. Oslin, 97, Executive Who Put Songs into Telegrams" by Eric Page, *New York Times*, October 29, 1996; *One Man's Century: From the Deep South to the Top of the Big Apple: A Memoir* by George P. Oslin. The name Lucille Lipps seemed too good to be true, raising worries that Oslin, obviously a creative sort, had made it up. How delightful then (whew!) to find Lucille in the 1930 US census records, which listed her as being twenty-five years old, living in Jersey City, New Jersey, and working as an operator for Western Union.

A Class Act: "Music: Pop Records," *Time*, October 5, 1969; "Jimmy Driftwood, 91, Singer-Songwriter," *New York Times*, July 14, 1998; *Country Music: The Rough Guide* by Kurt Wolff and Orla Duane.

Rewriting Rollo: *Love Me Tender* by Max Cryer; various articles in the *New York Times*; "Rudolph the Red-Nosed Reindeer," Snopes.com, http://www.snopes.com/holidays/christmas/rudolph.asp.

Cutting-Room Floor: *America's Songs* by Philip Furia and Michael Lasser; *The American Popular Ballad of the Golden Era, 1924–1950* by Allen Forte; *The Making of the Wizard of Oz: Movie Magic and Studio Power in the Prime of MGM* by Aljean Harmetz.

A Soldier's Song: *Lili Marlene: The Soldiers' Song of World War II* by Liel Leibovitz and Matthew Miller; "When Lilli Went to War—For Both Sides" by Derek Jewell, *New York Times*, November 19, 1967.

Gadzooks!: "Bob Burns Dead, Radio Comedian," *New York Times*, February 3, 1956; *Stars and Stripes*, March 1, 1918.

High School Musical: *Sondheim and Company* by Craig Zadan; "Stephen Sondheim and Frank Rich Stage A Little Night Conversation" by Charles Donelan, *Santa Barbara Independent*, Thursday, March 6, 2008.

Angry Angus: "Did He Ever Return? The Forgotten Story of 'Charlie and the M.T.A.'" by Peter Dreier and Jim Vrabel, *American Music*, vol. 28, no. 1 (Spring 2010), accessed at http://muse.jhu.edu/

login?uri=/journals/american_music/v028/28.1.dreier.pdf. Sam Berman, who sang lead vocal when the song was first recorded in 1949, lives here in Lexington, Massachusetts, and my wife and I have enjoyed the opportunity to talk with him and sing along with him on this song.

This *Is* Your Father's Oldsmobile: *1001 Songs: The Great Songs of All Time and the Artists, Stories and Secrets Behind Them* by Toby Creswell; "We Record Anything-Anywhere-Anytime: Sam Phillips & the Early Years of the Memphis Recording Service" by Davia Nelson and Nikki Silva, *NPR's Lost and Found Sounds,* http://www.npr.org/programs/lnfsound/stories/990917.stories.html; "Sam Phillips, Who Discovered Elvis Presley, Dies at 80" by Douglas Martin, *New York Times,* August 1, 2003.

Legacy of Lincoln: *Music for the Common Man: Aaron Copland During the Depression and War* by Elizabeth Bergman; *The Gettysburg Gospel* by Cabor Boritt; *Lincoln on Democracy* by Mario Matthew Cuomo.

Just Blowing His Horn: "The Day Louis Armstrong Made Noise" by David Margolick, *New York Times,* September 23, 2007; "Louis Armstrong Blasts Little Rock, Arkansas" by Michael Meckna, *Perspectives on American Music Since 1950* edited by James R. Heintze.

If I Needed Someone: "The Day John Met Paul" by Paul Coslett, BBC Online, http://www.bbc .co.uk/liverpool/content/articles/2007/07/03/john_met_paul_feature.shtml; "Til there Was You" by Andrew Marton, *Fort Worth Star-Telegram,* July 6, 2007.

All That Jazz: *A Great Day in Harlem,* a film by Jean Bach; "Jazz's Most Iconic Photo Is Half a Century Old" by Allen Kurtzhttp, Jazz.com, http:// www.jazz.com/features-and-interviews/2008/8/11/ jazz-s-most-iconic-photo-is-half-a-century-old.

What's That Fuzz?: *Fuzz & Feedback: Classic Guitar Music of the '60s* by Tony Bacon; *Keith Richards: The Biography* by Victor Bockris; *How Nashville Became Music City, U.S.A.: 50 Years of Music Row* by Michael Kosser.

The Anniversary Waltz: *Lonely Avenue: The Unlikely Life and Times of Doc Pomus* by Alex Haberstadt; "Doc Pomus Still Writes, Rocks, and Rambles" by Robert Palmer, *New York Times,* July 25, 1986.

Listen to the Music: *Louie Louie* by David Marsh; information on display at the Music Experience Project in Seattle, Washington.

Dream On: *The Beatles Anthology* by The Beatles; *The Beatles: Day-by-Day, Song-by-Song, Record-by-Record* by Craig Cross.

Thanks, Coach: *Lynyrd Skynyrd: Remembering the Free Birds of Southern Rock* by Gene Odom and Frank Dorman; *Lynyrd Skynyrd History,* http://www.lynyrdskynyrdhistory.com; various articles in the *New York Times.*

Adventure Capital: *Young Men with Unlimited Capital* by Joel Rosenman and John Roberts; *Woodstock: The Oral History* by Joel Makower and Michael Lang; "How Woodstock Happened," *Times Herald-Record*, Woodstock Commemorative Edition, 1994, accessed at http://www.edjusticeonline.com/woodstock/history/index.htm.

The King and I: Various primary source materials found on the *National Security Archive*, http://www.gwu.edu/~nsarchiv/nsa/elvis/elnix.html.

A Bronx Tale: "Music: Hip-Hop Nation" by Christopher John Farley et al., *Time*, February 8, 1999; *Hip-Hop, A Short History* by Rosa Waters; *Black Popular Music in America* by Arnold Shaw.

Smoke Gets in Your Eyes: *Smoke on the Water: The Deep Purple Story* by Dave Thompson; *Electric Don Quixote: The Definitive Story of Frank Zappa* by Neil Slaven. Since much of this story is told in the lyrics of the song, you might not think it would qualify as a little-known story. But a snap poll of twenty people found three who could identify what the song was about. This brought to mind the time one friend asked her young daughter for a definition of rock 'n' roll, and the little girl defined it as "music where the words don't matter." Apparently so.

Empty Orchestra: "TIME 100: Daisuke Inoue" by Pico Iyer, *Time Asia*, August 23–30, 1999.

Last Call: Arlo Guthrie has told this story on many occasions, one of which was the 1985 Steve Goodman Tribute concert captured on the album *Steve Goodman Tribute;* "'City of New Orleans' Rides Again" by Dave Hoekstra, *Chicago Sun Times*, December 4, 2005.

The Long and Winding Road: "Living in the Shadow of a Famous Song" by Steve Pond, *New York Times*, June 8, 1997; "The Killing Me Softly Story," *New York Daily News*, April 5, 1973; "'Killing Me Softly' (The Story Behind It)," video clip of an interview with Lori Lieberman, Current.tv, http://current.com/entertainment/music/92257287_killing-me-softly-the-story-behind-it.htm.

The Truth Will Set You Free: *A Chorus Line and the Musicals of Michael Bennett* by Ken Mandlebaum; "It Started with Watergate," *Time*, July 28, 1975.

Preaching to the Choir: *Serendipity: Accidental Discoveries in Science* by Royston M. Roberts; *Breakthroughs* by P. R. Nayak et al.

New York State of Mind: *Colored Lights* by John Kinder, Fred Ebb, and Greg Lawrence; "New York, New York," part of NPR's "Present at the Creation" series, http://www.npr.org/programs/morning/features/patc/newyorknewyork/index.html.

The Lullaby of Broadway: "Gower Champion Dies Hours Before Show Opens" by John Corry, *New York Times*, August 26, 1980; "Champion's Death Came on the Eve of Triumph" by Richard Shephard, *New York Times*, August 27, 1980.

What Can Brown Do for You?: *Crazy from the Heart* by David Lee Roth.

The Singing Revolution: *The Singing Revolution,* a film by Maureen and James Tusty; "The Sound of Freedom," Tallinn-Life.com, http://www.tallinn-life.com/tallinn/estonian-singing-revolution; various articles in the *New York Times.*

The Amazing Bone: "Playing Flute May Have Graced Neanderthal Fire" by Jon Noble Wilford, *New York Times*, October 29, 1996; "The Origins of Music: Innateness, Uniqueness, and Evolution" by Josh McDermott and Marc Hauser, *Music Perception: An Interdisciplinary Journal*, vol. 23, no. 1 (September 2005), accessed at www.jstor.org/stable/40285943.

Lost and Found: "A Pianist for Whom Never Was Never an Option" by Holly Brubach, *New York Times*, June 10, 2007; "Leon Fleisher's Long Journey Back to the Keyboard" by Naomi Graffman, *New York Times*, September 12, 1982; "Leon Fleisher," Explore the Arts Online, http://www.kennedycenter.com/explorer/artists/?entity_id=4306&source_type=A.

Come Tumblin' Down: "Rhyme and Punishment," *The Guardian*, February 21, 2004; various articles in the *New York Times.*

Rocking the Cosmos: "Queen's Brian May Rocks Out to Physics, Photography," NPR's *Fresh Air*, http://www.npr.org/templates/story/story.php?storyId=128935865.

ACKNOWLEDGMENTS

It is traditional for an author to *end* the acknowledgments section with words of praise for his or her spouse. I'm breaking with that tradition here and now. My wife, Marilyn Rea Beyer, is virtually a coauthor on my books and deserves to be mentioned up front. She provides excellent story ideas, clear-eyed feedback, creative writing ideas, expert copyediting, and boatloads of moral support. She pores over each manuscript looking for ways to improve it and usually has no problem finding them! Her musical expertise has proved particularly helpful on this book. I gratefully acknowledge the immeasurable contributions she has made to *The Greatest Stories Never Told* books and celebrate the wonderful quarter century we have shared together.

This book series was born out of the *Timelab 2000* history minutes I produced for HISTORY®. I owe a debt of gratitude to Artie Scheff for bringing me on to produce that project, which has led to so many rich experiences. Many others at HISTORY® have also been incredibly helpful and supportive over the years, including Abbe Raven, Nancy Dubuc, Susan Werbe, Libby O'Connell, Carrie Trimmer, Kate Winn, Lynsey Birnbaum, and Robert Brande. Thanks to each and every one of you.

The Levine-Greenberg Literary Agency has ably represented me for nearly a decade. Thanks to Arielle Eckstut, who first shepherded this project into existence, and Jim Levine for his expertise and oversight the last few years. A special shout-out to all the other folks there who help iron out all the wrinkles and keep things going smoothly.

At HarperCollins, editor Mauro DiPreta has been a tireless champion of the series, guiding it with a firm hand and a gentle touch. I can't imagine having a more supportive editor—insert superlative here! Associate editor Jennifer Schulkind is always patient and cheerful—how does she do that? I am grateful to everyone at HarperCollins, including many people I'm sure I've never met, who have labored on behalf of these books over the years.

Many people contributed story ideas for this book. I would specifically like to thank Marilyn Rea Beyer, Robert T. Beyer, Tim Brooks, Susan Cattaneo, Harry Forsdick, Matt Grayson, Richard Mark, Martin Mayer, Tony Rudell, David Rushke, David Seubert, Diane Taraz, and the pianist at the Carousel bar at the Monteleone Hotel in New Orleans for suggestions that made it into the book. Tim Brooks gets a second mention for being kind enough to scrutinize the in-progress manuscript and make some precise and valuable suggestions.

The National Archives and the Library of Congress are two invaluable national treasures. Any author looking to illustrate American history with archival photographs, drawings, and maps knows what amazing resources these are. At the University of California–Santa Barbara, the Cylinder Preservation and Digitization Project is chock-full of early recordings available on the Internet. Closer to home, the Boston Athenaeum and the Cary Memorial Library in Lexington are wonderful institutions with dedicated and knowledgeable staff. Thanks to all for invaluable assistance provided on this book.

My name goes on the front of the book, but an awful lot of other people work just as hard to create the product you hold in your hands. Let me single out Leah Carlson-Stanisic, who developed the interior design and laid out the pages; senior production editors Shannon Ceci and David Koral; production manager Eric Levy; and Mucca Design for the cover. If you could see the manuscript before copy editor Laurie McGee got her hands on it, you would know how important her contribution was!

Finally, I would like to make mention of my dad, Robert T. Beyer, who passed away two years ago. He was an internationally respected scientist whose passion for such things as history, language, and literature prompted a colleague to call him "a man for all seasons." Long ago he inspired my deep interest in history, and among the many gifts he gave me, that may be the most enduring. Although he is not around to read this book, it is nonetheless written for him.

Unless otherwise noted, photo credits for each page are listed top to bottom, and images are listed only the first time they appear. Credits for pages not listed can be found on the facing page. Every effort has been made to correctly attribute all the materials reproduced in this book. If any errors have been made, I will be happy to correct them in future editions.

Abbreviations:

BPL Boston Public Library Print Department
GI: Getty Images
LOC: Library of Congress
NARA: National Archives and Record Administration
SI: Smithsonian Institution
USPTO: United States Patent Office

Page x: GI; **Page 1:** GI; **page 2:** author, GI; **pages 4–5:** LOC; **pages 6–7:** GI; **page 8:** LOC; **page 9:** GI; **pages 10–11:** LOC; **page 12:** National Music Museum, the University of South Dakota; **page 13:** LOC, author; **page 14:** LOC, © National Portrait Gallery, London; **page 15:** LOC; **pages 16–17:** author; **pages 18–19:** LOC; **page 20:** Lebrecht Music And Arts, GI; **page 21:** LOC; **page 22:** LOC, Cowper and Newton Museum; **page 23:** LOC; **page 24:** LOC, NARA; **page 25:** author; **page 26:** GI, LOC; **page 27:** Wikimedia Commons; **pages 28–29:** LOC; **pages 30–33:** LOC; **page 34:** SCOTLANDSIMAGES.COM National

Trust for Scotland, LOC; **page 35:** author; **page 36:** author (photograph taken at Lexington High School, courtesy of Jeff Leonard), USPTO; **page 37:** GI, author; **pages 38–39:** LOC; **pages 40–41:** Scituate Historical Society (all except lighthouse), author; **page 42:** Lebrecht Music and Arts, LOC; **page 43:** ATN Archivi di Teatro Napoli; **page 44:** author; **page 45:** author, University of Maryland, LOC; **page 46:** illustration by David White, Koninklijke Bibliotheek; **page 48:** LOC, GI; **pages 50–53:** LOC; **page 54:** Naval History Center; **page 55:** LOC; **page 56:** LOC, GI; **page 57:** author (photograph taken at Lexington High School, courtesy of Jeff Leonard); **page 58:** LOC, GI; **page 59:** LOC; **page 60:** LOC; **page 61:** photographs by Mark Avino, National Air and Space Museum, Smithsonian Institution; **page 62:** LOC, GI; **pages 65–65:** LOC (all except sheet music), Duke University; **page 66:** the David Giovannoni Collection; **page 67:** Firstsounds.org, licensed under the Creative Commons (original images of phonoatograms held by Académie des Sciences de l'Institut de France); **pages 68–72:** LOC; **page 73:** author (all except Butterfield), LOC; **pages 74–75:** sheet music, LOC, photographs of clock taken by author at Buckman Tavern, courtesy of the Lexington Historical Society; **pages 76–77:** author (except Tchaikovsky), LOC; **pages 78–79:** LOC (except Nunes), Ukelele Hall of Fame Museum; **page 80:** Duke University; **page 81:** LOC; **page 82:** LOC, author; **page 83:** Science and Society Picture Library, LOC; **pages 84–85:** LOC (all except cake), author; **pages 86–87:** *Billboard* chart used with permission of Prometheus Global Media, *Billboard* cover courtesy of Prometheus Global Media, LOC; **pages 88–89:** painting courtesy RCA, photograph by Peggy Hurley, courtesy of Arnoff Moving & Storage; **pages 90–91:** LOC (all except Sabine), author; **pages 92–93:** LOC; **pages 94–95:** LOC (all except Bolden band), GI; **pages 96–99:** LOC; **pages 100–101:** Muzak LLC (except Wright plane), LOC; **page 102:** Lebrecht Music and Arts, LOC; **page 103:** LOC; **pages 104–7:** LOC; **page 108:** author, © RIA Novosti/Reuters/CORBIS; **page 109:** LOC; **page 110:** *Boston Globe, New York Times*; **page 111:** LOC; **pages 112–13:** LOC; **page 114:** GI, LOC; **page 115:** LOC; **pages 116–19:** LOC; **pages 120–21:** © Hulton-Deutsch Collection/CORBIS; ©Bettmann/CORBIS; **pages 122–23:** Peermusic (except Carters/Rogers), GI; **pages 124–25:** courtesy of the General Mills Archives (except radio), LOC; **pages 126–27:** GI (except keyboard), author (photograph taken at Lexington High School, courtesy of Jeff Leonard); **page 128:** LOC, GI; **page 130:** GI; **page 131:** GI, author; **page 132:** LOC, GI; **pages 134–35:** courtesy of the Dartmouth College Library, item located in Rauner Special Collections (all except Autry), LOC; **pages 136–37:** GI (all except Mayer), LOC; **page 138:** GI, LOC; **pages 140–41:** LOC (all except article), *New York Times*; **pages 142–43:** GI (all except Hammerstein), LOC; **page 144:** LOC, BPL; **page 145:** MBTA, photograph by Ida Berman; **page 146:** Plan 59; **page 147:** GI, LOC; **page 148–49:** LOC (all except Copland), Bernice Perry/Courtesy of the MacDowell Colony;

page 150: GI, LOC; **page 151:** *New Pittsburgh Courier*; **page 152:** illustration by Eric Cash, photograph by Rod Davis (who also appears in both!); **page 153:** Woolton Parish Church; **page 154:** photograph by Wyn Bullock, courtesy of Jonathan Kane; **page 155:** photograph of camera by Peter Hovmand, photograph *Harlem 1958* by Art Kane, courtesy Jonathan Kane; **page 156:** USPTO, Alex Stiber; **page 157:** GI; **pages 158–59:** GI; **page 160:** GI, BPL; **page 161:** © Neal Preston/CORBIS (Berry); **page 162:** GI; **page 163:** author, GI; **page 164:** photograph by Subwayatrain, licensed under the Creative Commons, *Florida Times Union*; **page 165:** GI; **page 166:** Woodstock Ventures; **page 167:** GI; **pages 168–69:** NARA; **pages 170–71:** GI; **page 173:** GI, Cantos Music Foundation; **page 174–75:** Getty Images (except mic), Publicdomainpictures.net; **page 176:** GI, © Bettmann/CORBIS; **pages 178–79:** GI; **page 180:** LOC; **page 181:** © Bettmann/CORBIS; **pages 182–83:** 3M (all except organ), LOC; **page 184:** GI, © Alan Pappe/CORBIS, GI; **page 186:** © John Springer/CORBIS, GI; **page 188:** Getty Images, author (this is a reconstruction based on the actual contract rider); **page 189:** author; **pages 190–91:** images by unknown videographers, provided by James Tusty and Maureen Castle, Singingrevolution.com (except handholding); AP Images; **page 192:** photograph by Toma Lauko, courtesy of the National Museum of Slovenia, LOC; **pages 194–95** (except Wittgenstein), Lebrecht Music and Art; **pages 196–97:** GI; **page 198:** NASA, GI; **page 199:** GI.

"The M.T.A." by Jacqueline Steiner and Bess Hawes, © 1956–1957/1984–1985 Atlantic Music Corp. Used by permission.

"Battle of New Orleans" by Jimmy Driftwood, © Warden Music Co., Inc. Used by permission.

"City of New Orleans" by Steve Goodman, © Jurisdad Music o/b/o itself & Turnpike Tom Music. Used by permission.

"A Dying Cub Fan's Last Request" by Steve Goodman, © Big Ears Music, Inc. o/b/o itself & Red Pajamas Music. Used by permission.